Bassett's
Roseville
Prices

Revised 2nd Edition

Mark Bassett

4880 Lower Valley Road, Atglen, PA 19310
USA

Published by Schiffer Publishing Ltd.
4880 Lower Valley Road, Atglen, PA 19310
Phone: (610) 593-1777; Fax: (610) 593-2002
E-mail: Schifferbk@aol.com
Please visit our web site catalog at
www.schifferbooks.com

This book may be purchased from the publisher.
Include $3.95 for shipping. Please try your bookstore first.
We are interested in hearing from authors with book ideas
on related subjects. You may write for a free catalog.

In Europe, Schiffer books are distributed
by Bushwood Books,
6 Marksbury Ave., Kew Gardens,
Surrey TW9 4JF England
Phone: 44 (0) 208 392-8585; Fax: 44 (0) 208 392-9876
E-mail: Bushwd@aol.com
Free postage in the U.K., Europe; air mail at cost.

Copyright © 2001 by Mark Bassett
Library of Congress Control Number: 2001090468

Designed by Douglas Congdon-Martin
Type set in Zurich BT

ISBN: 0-7643-1378-9

Printed in China

Cover Photos

- *Top left:* **Russco.** 702-12" vase, green, unmarked. *Author's collection.* $600-700.
- *Top right:* **Early Velmoss.** 138-12" vase, wheel thrown, hand decorated, black crayon shape number. *Author's collection.* $850-1000.
- *Center left:* **Futura.** 389-9" vase, "Emerald Urn." *Author's collection.* $700-800.
- *Center right:* **Ferella.** 506-8" vase, brown. *Author's collection.* $700–800.
- *Bottom left:* **Baneda.** 592-7" vase, pink. *Private collection.* $475-550.
- *Bottom right:* **Falline.** 651-8" vase, blue. *Author's collection.* $1500-2000.
- *Spine:* **Rozane Pattern.** 2 flame ornament, blue; 11-15" vase, blue; 7-9" vase, blue. *Author's collection.* $150-175; $400-500; $175–200.

CONTENTS

"Those things that bring charm and beauty into our lives are counted among our most cherished possessions. Hence, it is that Roseville Pottery has been so greatly prized for more than a generation."

-from a factory advertisement
House Beautiful,
October 1928

INTRODUCTION

One of my prized Christmas gifts of childhood was the two-volume set of the *Alice in Wonderland* stories. Like Alice, at that age I would have asked, "What is the use of a book without pictures?" Forty years later, I sometimes think, "What good is a reference book without any text?" Blame it on graduate school, but I prefer books that last longer than a single publishing season—books whose new research or new perspective "contributes to general knowledge."

At first glance, *Bassett's Roseville Prices* may seem to offer neither pictures nor text—just rows of shape numbers and prices. Indeed, **fair market values are cited for every Roseville line—by color,** when appropriate. But as this introduction will explain, this book is not just another Roseville price guide. *In Bassett's Roseville Prices the shape numbers themselves (and the Index) add another chapter to the story of Roseville Pottery.*

Why I Wrote This Price Guide

While working on *Introducing Roseville Pottery,* I found that not all Roseville shapes are illustrated or mentioned in the known factory records. Whenever possible, I photographed these pieces for the book. Some turned out to be marked with shape numbers, but most were not. Browsing through the older Roseville price guides, I located additional otherwise undocumented shapes.

To simplify matters, I decided to limit the shape lists in *Introducing Roseville Pottery* to those numbers appearing in the factory records. At the time, I expected to publish expanded shape lists in *Understanding Roseville Pottery* (forthcoming).

In early 1999, Peter Schiffer asked me to write a Roseville price guide. He knew that *Introducing Roseville Pottery* contained shape lists for more than 130 different Roseville lines. Work on the price guide, Peter suggested, would be fairly easy because the shape lists were already completed. Little did we know how much I still had to learn about Roseville shape numbers!

Aside from factory records, actual pieces of pottery are the only source that can identify Roseville shape numbers. For lines introduced before 1936, many pieces are not marked with a shape number. If they are, the shape number can be inkstamped or die-impressed on the bottom; sometimes it is hand-written in pencil or crayon. After the shape number one sometimes finds either a hyphen or a slash mark, followed by the longest dimension (in inches). Factory measurements were rounded off to the nearest inch or half inch.

Unfortunately, the information gathered from actual pots is not guaranteed to be reliable. If a crayon shape number were applied over the final glaze, it can be partly worn away. Owing to differences in handwriting, a "5" can sometimes look like a "6," or vice versa. Factory workers are known to have made occasional mistakes in marking the pots. And a few errors in shape numbers even appear to have crept into official factory documents!

For pieces made about 1936 or later, the shape number and size are almost always part of a permanent, die-impressed or raised-relief mark on the bottom. Identifying shape numbers for these lines is usually easy. Yet if the marks are not crisply molded or impressed, or if the glaze is heavy, even permanent shape numbers can be difficult to read—increasing the likelihood of error.

Developing comprehensive shape lists for the many Roseville lines is obviously a project that will require some time. Because *Bassett's Roseville Prices* will be periodically updated, it will also reprint the revised Roseville shape lists, as they grow and evolve.

Bassett's Roseville Prices makes a good companion to *Introducing Roseville Pottery* and is based on the same research. In that book I recommended several changes in terminology and dating. Two previously unknown lines (Early Velmoss and Keynote) were also identified as Roseville. For all these reasons, it made sense to publish *Bassett's Roseville Prices* before my next book, *Understanding Roseville Pottery.*

Revising the Shape Lists

As part of my project to expand the Roseville shape lists, I consulted the two works by Sharon and Bob Huxford (*The Collectors Encyclopedia of Roseville Pottery, 1st Series,* and *The Collectors Encyclopedia of Roseville Pottery, 2nd Series*). Roseville collectors refer to these two "pioneer" reference books as "Huxford I" and "Huxford II," respectively. Systematic study of the Huxfords' photographs—and cross-checking against the factory stock pages in Jack and Nancy Bomm's *Roseville in All Its Splendor*—identified many otherwise undocumented Roseville designs.

I also studied the shape lists in two recent Roseville price guides—by John W. Humphries (*A Price Guide to Roseville Pottery by the Numbers,* 15th ed.), and by Gloria and James Mollring (*Roseville Pottery: Collector's Price Guide, plus Impressed/Embossed Index,* 5th ed.). Both books included additional shape numbers for Roseville pieces that have now been identified and photographed for *Understanding Roseville Pottery.* Unfortunately, both Humphries and Molling also list many shape numbers that I

have not been able to authenticate. As explained above, some of these numbers may be in error—caused by a nearly illegible mark, or by a typographical or transcription error. Others may be unusual shapes that have not yet surfaced during my research.

Comparing various measurements cited in the four price guides reminded me that not everyone is familiar with a key measuring convention used at the Roseville Pottery: namely, *when measuring a bowl, fern dish, hanging basket, or jardiniere, the dimension cited is the* inside *diameter of the opening.* If one author measured the exterior diameter and another the interior, both could mistakenly believe some line to include two sizes of hanging baskets, instead of just one.

Gradually, my shape lists for *Bassett's Roseville Prices* are growing longer. In the interest of accuracy, I continue to omit any shape number that appears in an older Roseville price guide unless I have studied an example of the shape personally—either in a photograph or in real life.

From One Researcher to Another

Good fortune had it that, while preparing this price guide, I found myself becoming better acquainted with a friend I had made during the annual Pottery Lovers Reunion in Zanesville, Ohio. Thankfully, long-time Roseville collector and researcher Lou Haggis had been on the trail of "missing" Roseville shape numbers for about thirteen years. Through the use of Lou's files, I was able to match many more Roseville shapes with their shape numbers.

But I was even more excited by Lou's discovery— published here for the first time—of the previously unknown shape numbering system used at the Roseville Pottery Company. Working closely with Lou, I adapted his computer spreadsheet for publication as a shape index in *Bassett's Roseville Prices.* The result is, in my opinion **the most fascinating feature of this book,** "An Index to Roseville Shape Numbers, ca. 1916–1946" (located after the listings for Zephyr Lily).

Stated briefly, the Index demonstrates that *between 1916 and 1946 the Roseville Pottery Company assigned shape numbers by shape family.* By studying these orderly sequences, we can tell that most shape numbers for the 1916–1946 product lines have now been identified. The Index also clarifies the original factory-designated "shape family" for hundreds of Roseville pieces. In other words, it distinguishes between "bowls," "compotes," "vases," and other shapes. For a more detailed discussion of the Roseville shape numbering system, please see the Index itself.

For the Right Price

I sometimes think the authors of price guides could revise P.T. Barnum's well-known phrase to read: "You can please some of the people some of the time, but you can't please all the people *any* of the time!" Whatever price guide one follows, the buyer must eventually be willing to chance purchasing a particular pot. Like it or not, there is always some level of risk. Whatever intelligence we bring to the subject of value, there is a role to be played by intuition, a "good eye," and even dumb luck.

The values in *Bassett's Roseville Prices* reflect the author's fifteen years of experience in buying and selling Roseville—plus a working knowledge of dealers' asking prices, auction results, Internet sales (such as "ebay.com"), and other sources. Among the collectors and dealers who reviewed the pricing and other information in this edition of *Bassett's Roseville Prices* Lou Haggis; Gordon and Sue Hoppe; Frank Shannon; and Chester Sturm and Tom Wallwork, Fiesta Antiques (Harpers Ferry, WV). Thanks also the late Dave Auclair, Mike Nickel, and Jerry Scheytt, whose assistance with the first edition has continued to be useful.

Yet the Roseville market can be volatile. Prices drift up and down from season to season. It must be stressed that the values in this book are to be used for informational purposes only. They are intended only as a guide, not a certainty. **Neither the author nor the publisher can accept blame (or credit) for any losses (or gains) experienced through using *Bassett's Roseville Prices*.** Prices achieved can also be influenced by regional interest, the general economy, decorating fads, museum exhibitions, and the like.

When this price guide was written, two influences were holding prices down for Roseville's 1940s floral lines—especially small to middle-sized examples: the Internet and Chinese "reproductions." Internet auctions (particularly at "www.Ebay.com") make thousands of Roseville choices available to buyers nationwide on a daily basis. The "democracy" of the Internet serves to intensify competition among advanced collectors, thereby pushing prices higher for unusual and rare examples. At the same time, the large number of Roseville items on the Internet amounts to an increase in the supply of "beginner-level" pieces, causing their selling prices to decline.

As shown in *Introducing Roseville Pottery,* the recent Chinese copycats are easy for Roseville lovers to spot. Differences in glaze, texture, weight, clay color, and markings abound. Even so, there are sure to be some whose confidence has been shaken. The fear of being "taken" by an unscrupulous pottery merchant may explain why sales seem "off" in the $100 to $200 range, where new collectors generally buy.

Variables to Ponder

As explained in Chapter 2 of *Introducing Roseville Pottery,* condition *always* affects value. The price ranges shown in *Bassett's Roseville Prices* refer to examples in "mint" (which means "factory new") condition.

Damaged or restored examples must be priced lower than mint items. Hairlines are generally considered more serious than small chips, but either problem on a widely available piece can reduce values by as much as 50%.

Even with damage, differences in value are affected by relative rarity and demand. A short hairline on a Crystalis vase can be forgiven more easily than can a small chip on a Magnolia bowl. Clemana is scarce enough that some collectors are willing to overlook a minor nick.

It is also worth remembering that **any mint-condition Roseville pot with a high-quality glaze** (regardless of color) **and well-defined molded details will sell more quickly** (and often at a higher price) than a less distinctive example of the same shape.

Unless otherwise specified, any price in *Bassett's Roseville Prices* refers to *one* (1) piece of pottery—a single mug, bookend, or sugar bowl. If candlestick prices are given by the *pair,* a single candlestick should be priced at about 35–40% of the value of the pair. A stray jardiniere or pedestal should usually be priced around 25–35% of the value of the complete set. (Experience proves that it is difficult to "marry" a stray pedestal with a jardiniere of the proper size and color.)

On the other hand, a complete Roseville tea set (pot, creamer and sugar bowl) or tankard set (tankard and six steins) can be sold at a price around 10 to 20% higher than the sum of the individual values. Collectors appreciate the opportunity to purchase such a set intact.

Color and Quality

Every year, Roseville lovers expect to see a vogue for collecting one or two particular lines. One year, it's Futura, or Mostique; the next, Sunflower. Today a strongly colored line (like Fuchsia) tends to sell at a higher price than a pastel line (like Cremona), or a monochromatic line (like Ivory).

During the 1990s, many collectors avidly pursued several "blue" Roseville lines—including Pine Cone, Wisteria, and Falline. Another group of buyers chased "red" examples of Ferella. These sometimes temporary buying patterns have inspired at least one writer to value every Roseville line "by color."

Yet individual collectors have favorite colors, and favorite lines. They "buy what they like." Roseville prices are continually shifting, according to changes in supply and demand. *Bassett's Roseville Prices* takes a moderate approach to pricing "by color"—reflecting only well-established, long-term buying trends.

Some Roseville pieces—like Carnelian (Glazes) and green Russco—gain value according to the attractiveness of the glaze. Examples from decorated lines—like Rozane Royal and Della Robbia—are judged both by individual aesthetic merit and by the difficulty or skill involved in their decoration. In most such cases, the prices shown in *Bassett's Roseville Prices* refer only to the examples illustrated in *Introducing Roseville Pottery.*

A few Roseville pieces are so rare that predicting their probable "market value" is a game anyone can play. Olympic makes a good example. No one knows what these pots will actually bring until they appear on the market. In a few instances, such rarities have been "valued" by means of the abbreviation **NPD** (meaning "no price determined"). At the antique shop, auction, or show, fair market value is no higher than what a savvy long-term collector is willing to pay for "that special Roseville pot" on a given afternoon.

How High the Moon?

Beyond pricing information, collectors study price guides to learn more about their favorite Roseville lines. Unfortunately, *Bassett's Roseville Prices* can *not* contain all-inclusive shape lists for every Roseville line. Here is one problem: before 1916, many shapes were used in several different lines. The same shape could be available, for example, in Majolica, in Matt Green, and in Old Ivory (Tinted). Only after 1916 did a Roseville shape number generally refer to both a specific shape and a particular line.

Sometimes the degree of overlap between two Roseville lines is not known. The so-called "Crystal Green" line appears only in the factory stock pages for Ivory, making it uncertain that every shape was actually produced in both glaze treatments.

Some products—notably, Ivory and Tourmaline—relied heavily on reusing shapes that originated in earlier lines. So many shapes are shared between Rosecraft and Lustre that one might call Lustre a sub-set of the line Rosecraft. These complications make it difficult (perhaps impossible) to compile accurate and comprehensive shape lists for these lines.

The two 1920s Carnelian glaze treatments present another difficulty. The factory stock pages do not show a Carnelian (Drip) glaze treatment on any Carnelian vase numbered in the 400s. This observation leads collectors to assume that by 1928, when the 400 series of vases was introduced, no items were being produced at the factory as Carnelian (Drip).

Yet a few 400-series Carnelian vases are known to have an Early Carnelian glaze, which was thought to date to about 1916. (For an example, see the 440-8" vase illustrated

on page 119 of *Introducing Roseville Pottery*.) Was the Early Carnelian glaze used as late as 1928? This paradox has not yet been resolved.

If the shape number on your pot does *not* appear in *Bassett's Roseville Prices,* see Mark Bassett's *Introducing Roseville Pottery* to determine whether the design appears in factory records. Pre-1936 items without a shape number can sometimes be identified by browsing through Jack and Nancy Bomm's *Roseville in All Its Splendor*.

Tips for Beginners

For those just starting to buy Roseville pottery, it can be difficult to see the forest for the trees. If the sheer quantity of Roseville's production has you feeling confused, try narrowing your focus, as a means of building confidence. To avoid overlooking "sleepers" at the local antiques mall or show, you might first browse through *Bassett's Roseville Prices* to identify those items valued at $1000 or more.

Perhaps you could develop a rough guide to buying Roseville "by the inch." If it turns out that most 6" vases in a given line sell in the $100–125 range, and that most 8" vases sell in the $175–225 range, you could conclude that Pattern A is currently valued at about $25 an inch. This approach might help simplify your buying decisions.

Another possibility is to temporarily limit your buying to just one shape family—such as Roseville baskets. Studying the current values for baskets can help you identify the patterns whose baskets demand the highest price today.

More adventuresome collectors and dealers sometimes adopt the motto, "Quality sells." They choose to focus only on "high-end" items—perhaps those with a current value of $500 or more. The theory is that, over the long term, these expensive items will remain in greater demand than will the smaller, less decorative examples.

Author! Author!

For most lines introduced after 1916, *Bassett's Roseville Prices* lists all shapes that are currently known to the author. ***An asterisk before the name of a line indicates that it is the author's goal to identify every single shape that Roseville made in that line.*** You can help! Anyone who locates a Roseville piece bearing an otherwise unknown shape number—or a piece that is not illustrated in either Bassett or Bomm—is asked to contact:

Mark Bassett
P.O. Box 771233
Lakewood, OH 44107

email: markbassett@angelfire.com

Please include a photograph of the pot, its longest dimension (to the nearest 0.25"), and a clear image of the bottom of the piece (even if not marked). Sometimes even a photocopy of the bottom of an unmarked pot can attribute a piece to Roseville or another pottery. *(Note: The author regrets that no appraisals can be made.)*

Newly documented shape numbers will be incorporated into future editions of *Bassett's Roseville Prices*, as will any necessary corrections. To study the shape lists on-line, visit www.angelfire.com/oh/markbassett/rushapes.html.

References to other books are made by the author's surname. The abbreviation "Bomm" refers to Jack and Nancy Bomm, *Roseville in All Its Splendor;* "Huxford I" refers to Sharon and Bob Huxford, *Collectors Encyclopedia of Roseville Pottery,* 1st Series; "Huxford II" refers to Sharon and Bob Huxford, *Collectors Encyclopedia of Roseville Pottery,* 2nd Series); and "Monsen II" refers to Randall B. Monsen, *Collectors' Compendium of Roseville Pottery,* Volume II. All boldface references are to Mark Bassett's *Introducing Roseville Pottery.* For economy, these boldface references omit the surname "Bassett"; instead, they begin with the letter "I," followed by the page number.

To interpret the references shown in parentheses, remember that the first Arabic numeral after the author's surname refers to the *page number.* Subsequent numerals (if any) refer to *row* and *item* (counting from the left). Examples: the reference under "Antique Matt Green"— which reads "**I/41**"—refers to Mark Bassett's *Introducing Roseville Pottery,* page 41. A reference under "Dahlrose"— which reads "Huxford I/79/2/2"—refers to Sharon and Bob Huxford, *Collectors Encyclopedia of Roseville Pottery,* 1st Series, page 79, row 2, item 2.

To order an **autographed** copy of the revised 288-page hardback book *Introducing Roseville Pottery,* send $39.95 (postage to be paid by the author) to Mark Bassett, P.O. Box 771233, Lakewood, OH 44107. (Ohio residents must add $2.80 sales tax.)

Roseville Line Names

In *Bassett's Roseville Prices,* Roseville lines are arranged alphabetically. The following is a list of the Roseville line names used in *Bassett's Roseville Prices.* Cross-references are also made to familiar nicknames that appear in older price guides.

For more information about the Roseville factory's original line names and the nicknames recommended by various Roseville researchers, see Mark Bassett's *Introducing Roseville Pottery* (Schiffer, 2001). Ordering information for the book appears on page 12.

Acanthus—see *Mayfair*
Antique Matt Green
Apple Blossom
Artcraft
Artwood
Autumn
Aztec
Azurean
Azurine, Orchid and
 Turquoise—see *Rosecraft*
Baneda
Banks—see *Cornelian* and
 Majolica
Bittersweet
Black Tea Pots—see *Utility*
 Ware
Blackberry
Bleeding Heart
Blended—see *Majolica*
Blue Porcelain—see
 Decorated Artware
Blue Tea Pots—see
 Decorated Artware
Burmese
Bushberry
Cal Art—see *Commercial*
Cameo
Capri—see also *Late Capri*
Carnelian (Drip), also
 known as "Carnelian I"
Carnelian (Glazes), also
 known as "Carnelian II"
Ceramic Design—see
 Creamware and *Old Ivory*
 (Tinted)
Cherry Blossom
Chloron
Clemana
Clematis

Coat of Arms—see
 Creamware
Colonial—see *Cornelian*
Columbine
Commercial
Connecticut Roseville—see
 Keynote
Conventional—see
 Creamware
Corinthian
Cornelian
Cosmos
Creamware
Cremo
Cremona
Crocus
Crystal Green
Crystalis
Dahlrose
Dawn
Decorated and Gold
 Traced—see *Creamware*
Decorated Artware
Decorated Landscape
Decorated Matt
Decorated Persian—see
 Creamware
Decorated Utility Ware—see
 Utility Ware
Della Robbia
Dogwood (Smooth),
 inaccurately called
 "Dogwood II"
Dogwood (Textured),
 inaccurately called
 "Dogwood I"
Donatella Tea Sets—see
 Creamware
Donatello

14

Opac ("opaque") Enamels—
 see *Utility Ware*
Orian
Osiris—see *Utility Ware*
Panel
Pasadena Planters
Pauleo
Peony
Persian—see *Creamware*
Pine Cone
Pine Cone Modern, also
 known as "Pine Cone II"
Poppy
Primrose
Quaker—see *Creamware*
Raymor Modern Artware
*Raymor Modern Stone-
 ware*, also known as
 "Raymor Dinnerware"
Raymor Two-Tone Casual,
 also known as "Raymor
 for the Gourmet"
Romafin—see *Utility Ware*
Rosecraft
Rosecraft Blended—see
 Early Carnelian
Rosecraft Hexagon—see
 Hexagon
Rosecraft Panel—see *Panel*
Rosecraft Vintage—see
 Vintage
Royal Capri
Rozane Egypto—see
 Egypto
Rozane Fudji—see *Fudji*
Rozane Fujiyama—see
 Fujiyama
Rozane Line
Rozane Mara—see *Mara*
Rozane Mongol—see
 Mongol
Rozane Olympic—see
 Olympic

Rozane Pattern
Rozane Royal
Rozane Woodland—see
 Woodland
Russco
Savona
Silhouette
Snowberry
Solid Colors, also known as
 "Matt Colors"
Special—see *Decorated
 Artware*
Sunflower
Sylvan
Teasel
Thorn Apple
Topeo
Tourist—see *Creamware*
Tourmaline
Trial Glaze Pieces
Tuscany
Unique—see *Decorated
 Artware*
Untrimmed Rozane—see
 Rozane Royal
Utility Ware
Vase Assortment
Velmoss, also known as
 "Velmoss II"
Velmoss Scroll—see *Early
 Rosecraft*
Vernco—see *Commercial*
Victorian Art Pottery
Vintage
Vista
Volpato
Water Lily
White Rose
Wincraft
Windsor
Wisteria
Woodland
Zephyr Lily

ANTIQUE MATT GREEN

550-4" jardiniere (I/41)	$100–125
550-12" jardiniere (I/41)	$700–800
909-9.75" cuspidor (I/41)	$500–600
1208-12" x 6.5" wall pocket (I/41/2/1)	$450–550
1211-12" wall pocket (I/41)	$350–450

300-4" jardiniere	$125–150
301-6" jardiniere	$150–175
302-8" jardiniere and 305-P pedestal	$1250–1500
303-10" jardiniere and 306-P pedestal	$1500–1800
309-8" basket	$225–275
310-10" basket (I/42)	$300–350
311-12" basket	$400–500
316-8" ewer	$200–225
318-15" ewer (I/42)	$850–1000
321-6" cornucopia	$125–150
323-8" cornucopia (I/42)	$125–150
326-6" bowl	$100–125
328-8" bowl	$150–200
329-10" bowl (I/42)	$175–225
330-10" bowl	$175–225
331-12" bowl (I/42)	$225–275
333-14" bowl	$275–325
342-6" rose bowl (I/42)	$175–225
351-2" candlestick (I/42) (pr)	$125–150
352-4.5" candlestick (I/42) (pr)	$175–200
356-5" flower pot and saucer	$175–225
359 bookend (pr)	$275–350
361-5" hanging basket	$275–325
366-8" wall pocket	$325–375
368-8" window box (I/43)	$150–175
369-12" window box	$200–225
371-C creamer	$75–85
371-P teapot	$275–350
371-S sugar bowl	$75–85
373-7" vase	$150–175
379-7" bud vase	$150–175
381-6" vase	$125–150
382-7" vase (I/42)	$150–175
383-7" vase	$275–325
385-8" vase (I/43)	$150–175
387-9" vase	$250–300
388-10" vase	$300–350
389-10" vase (I/42)	$275–325
390-12" pillow vase	$400–500
391-12" vase	$400–500
392-15" vase	$800–900
393-18" floor vase (I/43)	$1200–1500

*Comprehensive shape list (see page 12)

ARTCRAFT

376-15" x 4" x 6" window box, matte mottled green and tan (I/45)	$1500–2000
454-16" vase, matte tan (I/45)	$1500–2000
455-18" vase, glossy mottled aqua, an Imperial (Glazes) coloring (I/44)	$2500–3000
629-4" jardiniere, glossy dark "azurine" blue, a Rosecraft coloring (I/45)	$250–350
629-4" jardiniere, matte tan or green (I/44)	$275–350
629-6" jardiniere, matte tan or green (I/44)	$350–425
629-10" jardiniere & pedestal, green, blue & tan (I/2)	$2500–3000

*ARTWOOD

1050-3" planter (I/46) (each)	$30–40
1051-6" vase (I/46)	$75–100
1051/1050 3-pc. set (I/46) (set)	$150–200
1052-8" vase (I/46)	$125–150
1053-8" vase (I/46)	$125–150
1054-8.5" planter	$125–175
1055-9" planter	$125–175
1056-10" planter	$150–200
1057-8" vase	$150–200
1058-9" planter˙	$200–250
1059-10" vase	$175–225
1060-12" vase	$200–250
1061-10" bowl (I/46)	$150–200
1062-12" bowl (I/46)	$175–225

*Comprehensive shape list (see page 12)

AUTUMN

480-8" jardiniere (I/47)	$750–850
12.5" ewer (I/47)	$850–950
14.5" basin (I/47)	$500–600
Set, 12.5" ewer and 14.5" basin (I/47) (set)	$1500–2000

AZTEC

1-5" pitcher, dark blue, 3 colors,
 artist initial L (I/49) $400–450
1-11" vase, light blue, 5 colors (I/49) $500–600
2-6" pitcher, dark blue, 4 colors (I/49) $450–500
2-11" vase, light blue, 6 colors, artist
 initial R (I/48) $450–550
3-5" pitcher, gray, 3 colors (I/49) $350–400
3-11" vase, gray, 5 colors, ornate
 decoration (I/48) $700–800
4-10" vase, gray, 4 colors (I/49) $400–450
6-11" vase, dark blue, 6 colors (I/48) $500–600
15-6" vase, gray, 4 colors, artist initial C (I/49) $450–500
17-9" vase, dark blue, 5 colors,
 artist initial C (I/49) $500–600
20-9" vase, tan, 4 colors (I/48) $550–650
23-8" vase, gray, 5 colors (I/49) $500–600

AZUREAN

818-11.75" vase, landscape, artist
 initials AD (Anthony Dunlavy) (I/49) $3000–4000
834-6.5" vase, pansies (I/50) $750–950
851-6" vase, clover (I/50) $600–750
865-18" vase, nasturtiums, artist
 initials V.A. (Virginia Adams) (I/50) $2000–2500
936-8" chocolate pot, berries and
 leaves (I/50) $1500–1800
956-8" vase, grapes (I/50) $1200–1500
8.5" vase, shape similar to Vase
 Assortment 105, floral decoration (I/50) $950–1200

	Green	Pink
232-6" bowl	$500–600	$400–500
233-8" bowl	$550–650	$475–550
234-10" bowl	$650–750	$550–650
235-5" rose bowl (l/51)	$550–650	$475–550
237-12" bowl	$750–850	$650–750
587-4" vase	$400–450	$350–400
588-6" vase	$500–600	$400–500
589-6" vase	$550–650	$450–550
590-7" vase	$550–650	$450–550
591-6" vase	$600–700	$500–600
592-7" vase (l/51)	$550–650	$475–550
593-8" vase	$800–900	$700–800
594-9" vase (l/52)	$900–1000	$800–900
595-8" vase	$950–1200	$850–950
596-9" vase (l/52)	$1200–1500	$950–1200
597-10" vase	$1500–1800	$1200–1500
598-12" vase (l/52)	$1800–2200	$1500–2000
599-12" vase (l/52/1/2)	$2500–3000	$2250–2750
600-15" vase (l/52)	$3000–3500	$2750–3250
601-5" vase (l/51)	$450–500	$375–450
602-6" vase	$500–600	$425–475
603-4" vase	$450–550	$375–450
604-7" vase	$800–900	$650–750
605-6" vase (l/51)	$700–800	$600–700
606-7" vase	$750–850	$650–750
610-7" vase	$800–900	$650–750
626-4" jardiniere	$450–500	$400–450
626-5" jardiniere	$500–600	$450–500
626-6" jardiniere	$550–650	$500–550
626-7" jardiniere	$650–750	$600–700
626-8" jardiniere and pedestal	$4000–5000	$3000–4000
626-9" jardiniere	$1500–1800	$1200–1500
626-10" jardiniere and pedestal	$6000–7000	$5000–6000
1087-5" candlestick	$400–500	$375–450
1088-4" candlestick	$350–450	$325–375
1269-8" wall pocket	$3750–4250	$3500–4000

*Comprehensive shape list (see page 12)

*BITTERSWEET

800-4" jardiniere	$100–125
801-6" jardiniere	$150–200
802-8" jardiniere	$300–350
805-8" jardiniere and pedestal	$950–1200
808-6" basket	$175–225
809-8" basket	$225–275
810-10" basket	$275–325
811-10" basket (I/53)	$350–400
816-8" ewer	$150–200
822-8" cornucopia	$150–175
826-6" bowl	$100–125
827-8" bowl	$100–150
828-10" bowl	$125–175
829-12" bowl	$150–200
830-14" bowl (I/53)	$150–175
841-5" rose bowl	$125–150
842-7" rose bowl	$175–225
851-3" candlestick (pr)	$125–150
856-7" flower pot and saucer	$225–275
857-4" novelty flower holder	$125–150
858-4" novelty flower holder	$150–200
859 bookend (pr)	$275–350
861-5" hanging basket	$250–300
863-4" compote (I/53)	$100–125
866-7" wall pocket	$300–400
868-8" window box	$125–150
869-12" window box	$175–225
871-C creamer	$75–85
871-P teapot	$275–325
871-S sugar bowl	$75–100
872-5" vase	$100–125
873-6" double bud vase	$125–175
874-7" pillow vase	$150–200
879-7" vase (I/53)	$125–150
881-6" vase	$125–150
882-6" vase	$100–125
883-8" vase (I/53)	$150–175
884-8" vase (I/53)	$175–225
885-10" vase	$225–275
886-12" vase (I/53)	$250–300
887-14" vase (I/53)	$450–550
888-16" vase	$750–950

*Comprehensive shape list (see page 12)

*BLACKBERRY

226-6" bowl	$500–575
227-8" bowl	$550–650
228-10" bowl	$600–700
334-6.5" basket (I/6)	$1000–1200
335-7" basket	$1000–1200
336-8" basket	$1100–1300
348-5" hanging basket (I/54)	$1000–1200
567-4" vase	$450–550
568-4" vase (I/54)	$450–550
569-5" vase (I/54)	$550–650
570-5" vase (I/54)	$550–650
571-6" vase (I/54)	$600–700
572-6" vase	$600–700
573-6" vase (I/54)	$700–800
574-6" vase	$600–700
575-8" vase	$900–1000
576-8" vase (I/54)	$900–1000
577-10" vase (I/54)	$1400–1600
578-12" vase (I/54)	$1800–2200
623-4" jardiniere	$400–450
623-5" jardiniere	$450–550
623-6" jardiniere	$550–650
623-7" jardiniere	$800–900
623-8" jardiniere	$1000–1200
623-9" jardiniere	$1200–1500
623-10" jardiniere and pedestal	$5000–6000
623-12" jardiniere	$3500–4000
1086-4.5" candlestick	$375–450
1267-8" wall pocket	$1750–2000

*Comprehensive shape list (see page 12)

*BLEEDING HEART

6 bookends (pr)	$275–350
40 flower frog	$125–150
138-4" vase	$125–150
139-8" vase	$175–225
140-4.5" gate	$150–200
141-6" cornucopia (I/56)	$125–150
142-8" cornucopia	$175–225
359-8" basket	$375–450
360-10" basket	$450–550
361-12" basket, built-in flower frog	$600–700
362-5" hanging basket	$350–400
377-4" rose bowl	$125–150
378-6" rose bowl	$175–200
379-6" bowl	$125–150
380-8" bowl	$175–225
381-10" tray	$175–225
382-10" bowl	$175–200
383-12" bowl	$200–225
384-14" bowl	$275–325
651-3" jardiniere	$100–125
651-4" jardiniere	$150–200
651-5" jardiniere	$200–250
651-6" jardiniere	$250–300
651-7" jardiniere	$350–450
651-8" jardiniere and pedestal (I/9 and 56)	$1400–1600
651-10" jardiniere and pedestal	$2500–2750
652-5" flower pot and saucer	$200–225
961-4" vase	$100–125
962-5" vase (I/56)	$150–175
963-6" ewer	$225–275
964-6" vase	$175–200
965-7" vase (I/56)	$200–250
966-7" vase	$200–250
967-7" bud vase (I/56)	$150–200
968-8" vase (I/56)	$225–275
969-8" vase	$225–275
970-9" vase	$250–300
971-9" vase	$250–300
972-10" ewer	$325–375
973-10" vase	$325–375
974-12" vase	$375–450
975-15" ewer	$1200–1400
976-15" vase	$950–1200
977-18" floor vase (I/55)	$1400–1600
1139-4.5" candlestick (pr)	$250–300
1140 candlestick (pr)	$175–225
1287-8" wall pocket	$700–800
1323 pitcher	$500–600

*Comprehensive shape list (see page 12)

*BURMESE

70B candlestick, female (I/57) $125–150
71B bookend, male (I/57) $125–150
72B wall pocket, female $300–400
76B-3.5" candlestick (I/57) (pr) $75–100
80B candlestick, male (I/57) $125–150
81B bookend, female (I/57) $125–150
82B wall pocket, male $300–400
90B-10" window box (I/57) $100–125
91B-9" x 9" x 3.75" bowl, square $125–150
92B-14.5" window box (I/57 $125–150
96B-10" bowl, round $100–125

*Comprehensive shape list (see page 12)

*BUSHBERRY

Item	Price
1-3.5" mug	$125–175
1-6" ewer (I/59)	$150–200
1-10" compote	$200–250
2-C creamer	$85–100
2-S sugar bowl	$85–100
2-T teapot	$300–350
2-10" ewer	$250–300
3 cornucopia	$175–225
3-15" ewer	$850–950
9 bookend (I/59) (pr)	$325–375
26 ashtray (I/58)	$125–150
28-4" vase	$100–125
29-6" vase	$150–200
30-6" vase (I/58)	$125–175
31-7" vase	$175–225
32-7" vase	$175–225
33-8" vase	$200–250
34-8" vase (I/58)	$200–250
35-9" vase (I/58)	$200–250
36-9" vase	$225–275
37-10" vase (I/58)	$275–325
38-12" vase	$350–400
39-14" vase (I/59)	$400–500
40-15" vase	$800–900
41-18" floor vase	$1200–1400
45 flower frog	$125–150
152-7" bud vase	$125–175
153-6" cornucopia	$125–175
154-8" cornucopia	$150–200
155-8" double cornucopia	$200–250
156-6" vase (I/59)	$125–175
157-8" vase	$175–225
158-4.5" gate	$150–200
369-6.5" basket	$200–250
370-8" basket (I/59)	$275–325
371-10" basket (I/59)	$300–400
372-12" basket	$500–600
383-6" window box	$125–175
384-8" window box	$175–225
385-10" window box	$200–250
411-4" rose bowl	$125–175
411-6" rose bowl	$175–225
411-8" rose bowl (I/59)	$200–250
412-6" bowl (I/58)	$175–225
414-10" bowl	$175–225
415-10" bowl	$200–250
416-12" bowl	$175–225
417-14" bowl	$225–275
465-5" hanging basket	$350–400
657-3" jardiniere	$100–125

*BUSHBERRY *(cont.)*

657-4" jardiniere	$125–150
657-5" jardiniere	$150–200
657-6" jardiniere	$200–250
657-8" jardiniere and pedestal	$1200–1500
657-10" jardiniere and pedestal	$1500–1750
658-5" flower pot and saucer	$225–275
778-14" sand jar	$1400–1600
779-20" umbrella stand	$1400–1600
1147 candlestick (pr)	$125–150
1148-4.5" candlestick (pr)	$150–175
1291-8" wall pocket	$350–450
1325 ice-lip pitcher	$400–500

*Comprehensive shape list (see page 12)

CAMEO

339-12.5" wall sconce, owl (I/60) $2500–3000
416-6" jardiniere, flying geese (I/60) $350–450
489-7" jardiniere, Bacchantes (I/60) $750–950
510-10" x 30" jardiniere and pedestal,
 Art Nouveau lady and poppies (I/60) $2000–2500

508-7" basket	$125–150
509-8" basket (I/62)	$125–150
510-10" basket	$150–200
526-7" bowl	$60–75
527-7" bowl (I/61)	$50–60
529-9" bowl	$60–75
531-14" bowl	$100–125
532-15" bowl	$100–125
555-7" planter	$50–60
556-6" planter, cornucopia shape	$75–125
557-7" planter, vase shape	$100–125
558 planter, freeform	$75–100
569-10" window box (I/62)	$75–100
572-8" combination bud vase and planter	$100–125
580-6" vase (I/62)	$100–125
582-9" vase (I/61)	$100–125
586-12" vase (I/61)	$150–175
597-7" ashtray	$40–50
598-9" ashtray	$60–75
599-13" ashtray	$75–100
C1003-8" vase	$100–125
C1004-9" vase (I/61)	$100–125
C1009-8" bowl	$100–125
C1010-10" bowl	$100–125
C1012-10" basket	$125–175
C1016-10" vase	$125–150
C1017-12" vase	$150–200
C1118 bowl, shell shape	$75–100
C1119 bowl, shell shape	$100–125
C1120 bowl, shell shape	$100–125
C1151 candlestick, shell shape (pr)	$75–100

*Comprehensive shape list (see page 12)

CARNELIAN (DRIP)

50-4" flower holder	$125–150
52-6" fan vase (Bomm 84/3/1; misnumbered 352 in Mollring, 5th ed.)	$125–150
53-5" pillow vase (Bomm 84/3/5; misnumbered 353 in Mollring, 5th ed.)	$125–150
54-8" fan vase (I/64)	$150–175
57-3" candlestick/flower frog	$125–150
58-3.5" flower holder (I/64)	$100–125
60-6" flower frog, rock shape	$150–175
62-3.5" candlestick/flower holder (I/62)	$125–150
63-5.5" flower holder	$150–175
153-5" footed bowl (I/64)	$125–150
159-6" bowl	$125–150
160-7" bowl	$125–150
167-12" bowl (I/62)	$200–250
169-12" bowl	$200–250
306-6" bud vase (Bomm 84/7/3)	$125–150
308-7" vase (Bomm 84/6/4)	$175–200
309-6" vase (I/62)	$150–175
312-8" vase (I/33)	$200–250
317-10" vase (Bomm 84/8/2)	$250–300
318-8" vase (Bomm 84/6/6)	$250–300
319-10" vase (I/64)	$250–300
331-7" vase	$200–250
333-6" vase (I/64)	$250–300
334-8" vase	$275–325
335-8" vase (I/64)	$300–350
336-9" vase (I/64)	$300–350
337-10" vase	$325–375
1059-2.5" candlestick (pr)	$150–200
1060-3" candlestick (pr)	$175–225
1064-3" candlestick (I/64) (pr)	$225–275
1247-8" wall pocket (Bomm 84)	$350–400
1249-9" wall pocket (Bomm 84)	$375–450
1251-8" wall pocket (Bomm 83)	$375–450
1253-8" wall pocket (Bomm 83)	$375–450
1311-10" pitcher (I/64)	$400–500
1315-15" pitcher (I/64)	$700–800

CARNELIAN (GLAZES)

152-7" bowl (I/65)	$200–250
158-5" rose bowl (I/65)	$275–350
310-7" vase (I/64)	$350–400
312-8" vase (I/33)	$400–500
314-9" vase (I/65)	$375–450
334-8" vase (I/64)	$400–500
337-10" vase (I/65)	$700–800
339-15" vase (I/65)	$1200–1500
440-8" vase (I/119)	$1200–1500
441-8" vase (I/65)	$1200–1500
442-12" vase	$1200–1500
443-12" vase (I/65)	$1500–2000
445-12" vase	$1500–2000
446-12" vase (I/65)	$3000–4000
447-14" vase (I/198/2/I)	$1200–1500
448-15" vase (Huxford II/72/1/2)	$1500–2000
449-14" vase (Huxford II/72/3/2)	$2500–3000
450-14" vase (I/64)	$3000–3500
452-16" vase (I/65)	$2500–3000
455-18" vase (Huxford II/72/3/1)	$2500–3000
1064-3" candlestick (I/34)	$125–150
1248-8" wall pocket (Bomm 84)	$400–500
1251-8" wall pocket (Bomm 83)	$450–550
1252-8" wall pocket (Bomm 83)	$450–550
1253-8" wall pocket (Bomm 83)	$450–550

*CHERRY BLOSSOM

	Pink	Brown
239-5" bowl, flower pot shape	$450–550	$400–450
240-8" bowl	$500–600	$450–500
350-5" hanging basket	$2000–2500	$1500–1800
617-3.5" vase (I/66)	$400–500	$325–375
618-5" vase (I/66)	$500–600	$450–500
619-5" vase	$500–600	$450–500
620-7" vase (I/66)	$600–700	$500–550
621-6" vase	$600–650	$500–550
622-7" vase	$600–650	$550–600
623-7" vase	$650–700	$600–650
624-8" vase	$700–800	$650–700
625-8" vase	$850–1000	$800–900
626-10" vase	$1200–1400	$1000–1200
627-4" jardiniere	$400–500	$350–400
627-5" jardiniere (I/66)	$500–600	$400–450
627-6" jardiniere (I/66)	$600–700	$450–500
627-7" jardiniere (I/66)	$700–800	$500–600
627-8" jardiniere and pedestal	$2500–3000	$1750–2000
627-9" jardiniere	$1200–1500	$850–1000
627-10" jardiniere	$1800–2200	$1500–1800
627-10" jardiniere and pedestal	$4500–5500	$3500–4000
627-12" vase	$1800–2200	$1200–1500
628-15" vase (I/67)	$3500–4000	$2500–3000
1090-4" candlestick (I/66) (pr)	$700–800	$550–650
1270-8" wall pocket	$1500–1800	$1000–1200

*Comprehensive shape list (see page 12)

C15-8.5" vase, foliage, matte bright green,
Chloron inkstamp, TRPCo inkstamp (I/67) $750–850

C16-6.5" vase, berries and foliage, semigloss
dark green, die-impressed Chloron (I/68) $575–650

C17-5.5" vase, pears and cherries, charcoaled
matte green, unmarked (I/34) $400–500

C19-5.5" vase, flowers in arch-like
arrangement, matte light and
medium green, strong organic
texture, unmarked (I/68) $500–600

C21-6.5" vase, floral vine, matte
medium green, Chloron inkstamp (I/68) $400–500

*CLEMANA

23-4" flower frog (I/68)	$125–150
122-7" vase (I/69)	$350–400
123-7" pillow vase (I/21)	$300–350
280-6" rose bowl	$350–400
281-5" bowl (I/69)	$200–250
282-8" bowl	$250–300
283-12" bowl	$300–350
749-6" vase (I/68)	$250–300
750-6" vase (I/21)	$275–325
751-7" vase (I/69)	$325–375
752-7" vase (I/69)	$275–325
753-8" vase (I/69)	$350–400
754-8" vase (I/69)	$400–450
755-9" vase	$400–450
756-9" vase (I/68)	$500–550
757-10" vase	$500–600
758-12" vase	$600–700
759-14" vase (I/69)	$850–1000
1104-4.5" candlestick (pr)	$300–350

*Comprehensive shape list (see page 12)

*CLEMATIS

3-8" cookie jar (I/8)	$450–500
5-C creamer	$55–65
5-S sugar bowl	$55–65
5 teapot	$200–250
6-10" compote	$150–175
14 bookend (pr)	$225–275
16-6" ewer	$125–150
17-10" ewer (I/70)	$200–250
18-15" ewer	$500–600
50 flower arranger (I/70)	$75–100
102-6" vase	$100–125
103-6" vase (I/70)	$100–125
105-7" vase	$100–125
106-7" vase	$100–125
107-8" vase	$125–150
108-8" vase (I/71)	$125–150
109-9" vase (I/70)	$150–175
110-9" vase (I/70)	$175–200
111-10" vase (I/71)	$225–275
112-12" vase (I/70)	$275–325
114-15" vase	$500–600
187-7" bud vase	$100–125
188-6" vase	$100–125
190-6" cornucopia	$100–125
191-8" cornucopia	$100–125
192-5" vase	$100–125
193-6" vase	$100–125
194-5" gate	$100–125
387-7" basket (I/70)	$175–200
388-8" basket (I/70)	$200–250
389-10" basket	$250–300
391-8" window box (I/71)	$100–125
455-4" rose bowl	$75–100
456-6" bowl	$100–125
457-8" bowl (I/70)	$125–150
458-10" bowl	$150–175
459-10" bowl	$150–175
460-12" bowl (I/70)	$150–175
461-14" bowl	$175–200
470-5" hanging basket	$200–250
667-4" jardiniere	$75–100
667-5" jardiniere	$100–125
667-8" jardiniere and pedestal	$650–750
668-5" flower pot and saucer	$150–200
1158-2" candlestick (pr)	$85–100
1159-4.5" candlestick (I/22) (pr)	$100–125
1295-8" wall pocket	$200-250

*Comprehensive shape list (see page 12)

*COLUMBINE

8 planter bookend (I/72) (pr)	$325–400
12-4" vase	$100–125
13-6" vase (I/72)	$125–150
14-6" vase	$150–175
15-7" bud vase (I/72)	$125–150
16-7" vase (I/71)	$150–175
17-7" vase	$175–200
18-7" ewer (I/72)	$225–275
19-8" vase (I/72)	$175–225
20-8" vase	$175–225
21-9" vase (I/71)	$200–225
22-9" vase	$200–250
23-10" vase (I/72)	$275–325
24-10" vase	$250–300
25-12" vase	$375–450
26-14" vase	$600–700
27-16" vase	$950–1200
42 flower frog (I/72)	$150–200
149-6" cornucopia	$150–175
150-6" vase (I/72)	$150–175
151-8" vase	$200–225
365-7" basket (I/72)	$225–275
366-8" basket	$275–325
367-10" basket (I/72)	$325–375
368-12" basket	$450–550
399-4" rose bowl	$125–150
400-6" rose bowl	$175–200
401-6" bowl	$150–175
402-8" bowl	$175–200
403-10" bowl	$200–225
404-10" bowl	$175–225
405-12" bowl	$200–250
406-14" bowl (I/72)	$200–250
464-5" hanging basket	$275–350
655-3" jardiniere	$125–150
655-4" jardiniere	$150–175
655-5" jardiniere	$175–200
655-6" jardiniere	$225–275
655-8" jardiniere and pedestal	$1500–1800
655-10" jardiniere and pedestal	$1800–2200
656-5" flower pot and saucer (I/71)	$200–250
1145-2.5" candlestick (I/72) (pr)	$150–175
1146-4.5" candlestick (pr)	$200–250
1290-8" wall pocket	$700–800

*Comprehensive shape list (see page 12)

Borden's Set

B1 cup (I/73)	$175–250
B2-7.5" plate (I/73)	$400–500
B3 cereal bowl (I/73)	$250–300
3-pc. set (I/73)	$1000–1200

Hyde Park

1510 cigarette box (I/73)	$40–50
1900 ashtray on 22.5" metal stand (I/73)	$125–150
1930 ashtray (I/73)	$20–25
1940 ashtray (I/73)	$20–25
1950 ashtray (I/73)	$20–25

*CORINTHIAN

14-2.5" flower block (same as La Rose)	$40–50
14-3.5" flower block (same as La Rose)	$40–50
15-8" compote (Bomm 102/6/1)	$175–200
37 gate	$125–175
42 gate	$150–200
121-5" bowl (I/74)	$100–125
121-6" bowl (Bomm 102/5/3 lower)	$100–125
121-7" bowl (Bomm 102/6/3)	$100–125
121-8" bowl (I/74)	$125–150
212-6" vase (I/74)	$150–175
213-6" vase (I/74)	$175–200
214-6" vase	$175–200
215-7" vase (I/74)	$175–200
216-7" vase	$175–200
217-8" vase (I/27)	$150–200
218-8" vase	$150–200
219-10" vase (I/74)	$225–275
220-12" vase	$325–375
235-6" vase (I/74)	$150–175
235-8" vase	$200–250
235-10" vase	$250–300
235-12" vase	$275–325
235-15" vase	$500–600
255-5" fern dish	$150–200
255-6" fern dish	$175–225
256-5" fern dish	$175–225
256-6" fern dish	$225–275
336-6" hanging basket	$250–300
336-8" hanging basket	$275–325
601-5" jardiniere (I/74)	$150–175
601-6" jardiniere	$175–200
601-7" jardiniere	$225–275
601-8" jardiniere	$325–375
601-9" jardiniere	$450–550
601-10" jardiniere and pedestal	$1000–1200
601-12" jardiniere and pedestal	$1200–1500
603-5" flower pot and saucer (I/74)	$200–250
603-6" flower pot and saucer	$250–300
1048-8" candlestick	$150–200
1228-10" wall pocket	$275–325
1229-12" wall pocket	$325–400
1232-8" wall pocket	$300–350
20" umbrella stand (Huxford II/180/1/3)	$750–850

*Comprehensive shape list (see page 12)

E3-5" pitcher, corn, blue (I/77)	$150–200
E4-6" pitcher, corn, tan (I/77)	$150–200
4" cat bank (I/75)	$300–350
11.75" "Colonial" combinette (covered), blue (I/75)	$300–400
8" "Colonial" mouth ewer, cream (I/77)	$150–175
8" "Colonial" mouth ewer, blue (I/77)	$175–200
8" "Cornelian" pattern mouth ewer, yellow (I/77)	$150–200
10" x 4" fruit bowl, yellow (I/77)	$95–125
5" milk pitcher, from bread and milk set, cream	$95–125
5" pitcher, leaves (I/31)	$75–95
6.5" pitcher, leaves (I/31)	$95–125
1-pt. milk pitcher, yellow (I/77)	$75–95
15" pedestal for 421 jardiniere, blue (I/77)	$200–250

*COSMOS

39 flower frog (l/8)	$125–150
133-6" gate (l/78)	$200–250
134-4" vase	$125–150
135-8" vase	$225–275
136-6" cornucopia	$150–175
137-8" cornucopia	$175–200
357-10" basket (l/6)	$375–425
358-12" basket	$450–500
361-5" hanging basket	$325–375
369-6" bowl	$150–175
370-8" bowl	$150–175
371-10" bowl	$200–250
372-10" bowl	$200–250
373-12" bowl (l/79)	$250–300
374-14" bowl	$300–350
375-4" rose bowl	$150–200
376-6" rose bowl	$200–250
381-9" window box (l/79)	$250–300
649-3" jardiniere	$100–125
649-4" jardiniere	$150–175
649-5" jardiniere	$175–225
649-6" jardiniere	$275–350
649-8" jardiniere and pedestal	$1800–2000
649-10" jardiniere and pedestal	$2000–2500
650-5" flower pot and saucer	$325–375
944-4" vase	$100–125
945-5" vase	$125–150
946-6" vase (l/79)	$150–175
947-6" vase (l/79)	$175–200
948-7" vase (l/79)	$225–275
949-7" vase	$200–250
950-8" vase	$250–300
951-8" vase	$225–275
952-9" vase (l/79)	$250–300
953-9" vase (l/78)	$275–325
954-10" vase	$325–375
955-10" ewer	$325–375
956-12" vase	$375–450
957-15" ewer	$850–1000
958-18" floor vase (l/8)	$1200–1400
959-7" bud vase	$125–150
1136-2" candlestick (l/79) (pr)	$175–225
1137-4.5" candlestick (pr)	$250–300
1285-6" wall pocket	$450–500
1286-8" wall pocket	$500–600

*Comprehensive shape list (see page 12)

CREAMWARE

Baby Bunting

8" rolled-edge plate (I/85)	$250–300

Coat of Arms

6" tobacco humidor (I/85)	$250–300
10" tray (I/85)	$150–200

Conventional Floral Motifs

13-8" teapot (I/85)	$400–500
6.5" pitcher (I/85)	$200–250
4" soda glass (I/85)	$95–125
4" tumbler (I/85)	$95–125

Dutch

1-7.5" pitcher (I/86)	$275–325
13-8" teapot (I/86)	$400–500
15-5" stein (I/86)	$95–125
856-4.5" stein (I/86)	$95–125
1004 bedside candlestick (I/86)	$275–325
7.5" pitcher (I/86)	$200–300
5.5" covered soap dish (I/86)	$300–400
3.5" shaving mug (I/86)	$125–175
2.5" side-pour milk pitcher (I/86)	$95–125
5" toothbrush holder (I/86)	$175–225
10" tray (I/86)	$175–225

Forget Me Not

3" hair receiver (I/86)	$125–150
3" powder box (I/86)	$125–150
10" tray (I/86)	$125–175

Fraternal Societies

15-5" stein, Knights of Pythias (I/87)	$125–150
206-4" combination planter, Shriner (I/88)	$175–225
856-4.5" stein, Knights Templar (I/87)	$150–175
856-4.5" stein, Loyal Order of Moose (I/87)	$95–125
856-4.5" stein, Shriner (I/88)	$150–175
921-11" tankard, Loyal Order of Moose (I/87)	$200–250
921-11" tankard, Shriner (I/88)	$325–375
956-6.5" stein, Shriner, dated 1906 (I/84)	$550–650

Gibson Girl

810-8.75" vase (I/84)	$800–900

CREAMWARE *(cont.)*

Holly

205-4" fern dish (I/88)	$175–225
3.5" side-pour pitcher (I/88)	$225–275

Jeanette

545-6" jardiniere (I/88)	$175–225

Juvenile

1-3" mug, Puddle Duck (I/88)	$200–250
3-7" plate, Jack Rabbit (I/88)	$225–275
4.5" bowl, Sitting Rabbit (I/89)	$75–95
5.5" bowl, Sitting Rabbit (I/89)	$95–125
6" bowl, Sitting Rabbit (I/89)	$75–95
2" creamer, Sitting Rabbit (I/89)	$125–150
2.25" cup with 5.25" saucer, Sitting Rabbit (I/89) (set)	$150–175
3.5" milk pitcher, Sitting Rabbit (I/89)	$125–150
3" mug, Jack Rabbit (I/89)	$200–250
6.75" plate, Sitting Rabbit (I/89)	$95–125
8" rolled edge plate, Dog (I/88)	$150–200
8" rolled edge plate, Puppies (I/89)	$250–300
8" rolled edge plate, Sitting Rabbit (I/89)	$150–175
8" rolled edge plate, Sunbonnet Babies (I/88)	$125–150
3" side-pour creamer, Bear (I/89)	$400–500
3" side-pour creamer, Sitting Rabbit (I/89)	$95–125
3.75" sugar bowl, Sitting Rabbit (I/89)	$150–175
7" rolled-edge plate, Sitting Rabbit (I/89)	$125–150

Landscape

8" chocolate pot (I/89)	$250–300
9.5" coffee pot (I/89)	$325–375
2.75" creamer (I/90)	$125–150
3.5" ramekin (I/89)	$95–125
4.5" teapot (I/90)	$200–250

Medallion

6.5" chocolate pot (I/90)	$200–250
3" creamer (I/90)	$95–125
3.5" sugar bowl (I/90)	$95–125

Monk

15-4.5" stein (I/90)	$350–400

Novelty Steins

8-4.5" stein (I/90)	$175–225
856-4.5" stein (I/90)	$175–225

Nursery Rhyme

6.5" rolled-edge plate, Little Bopeep (I/91)	$125–150
8" rolled-edge plate, Hickory Dickory Dock (I/22)	$125–175
8" rolled-edge plate, Higgledy Piggledy (I/91)	$125–175
8" rolled-edge plate, Little Jack Horner (I/91)	$125–175
8" rolled-edge plate, Old Woman (I/91)	$125–175

Persian

315-5" hanging basket (I/91)	$400–450
330-11" wall pocket (I/10)	$450–550
462-5" jardiniere, leaves and berries (I/91)	$275–325
462-8" jardiniere, poppies (I/91)	$475–550
462-12" x 33" jardiniere and pedestal (I/11)	$2000–2500
523-10" combination jardiniere (I/92)	$600–700
3" creamer (I/92)	$125–150
3.5" sugar bowl (I/92)	$125–150

Quaker

821-12" tankard (I/92)	$350–400
897-5.5" humidor (I/92)	$275–350
4.75" teapot (I/92)	$225–275

Tourist

5-9" x 6" vase (I/93)	$1500–2000
226-5" fern dish (I/93)	$950–1200
362-14" x 8" window box (I/93)	$2800–3200
569-7" jardiniere (I/93)	$2000–2200
569-9" jardiniere (I/93)	$2200–2500
569-10" jardiniere (I/93)	$2500–2800

Miscellaneous

213-3.5" combination planter, stippled (I/85)	$95–125
328-10.75" wall pocket, Traced and Decorated (I/10)	$450–550
353-9" candlestick, gold traced (I/85)	$125–150
545-8" jardiniere, Mercian (I/1)	$1200–1500
545-10" jardiniere, Mercian (I/39)	$1200–1500
E60-3.75" candlestick, gold traced (I/84)	$200–250
2" ashtray, advertising lettering (I/85)	$75–125
2" chamberstick, orange band (I/84)	$125–175
3.5" covered oval pin box, rose decals, blue band (I/84)	$200–250

CREAMWARE *(cont.)*

3.5" shaving mug, scroll decal (I/84) $125–175
3.5" side-pour pitcher, Greek key decal
 and gold band (I/84) $95–125
4" pitcher, "ideal" shape, undecorated (I/84) $60–75
4" sugar bowl, rose decals, green band (I/84) $75–95

CREMO

4-6.5" vase (I/94)	$1500–2000
9-5" vase (I/94)	$1200–1500
12-8" vase (I/94)	$2000–2500

*CREMONA

72-4" vase	$150–175
73-5" fan vase (I/95)	$150–200
74-6" vase	$175–225
75 flower frog, rock shape	$100–125
176-6" bowl	$150–200
177-8" bowl	$175–225
178-8" bowl	$200–250
351-4" vase (I/95)	$175–225
352-5" vase	$175–225
353-5" vase	$175–225
354-7" vase	$200–250
355-8" vase (I/95)	$250–300
356-8" vase	$275–325
357-8" vase	$275–325
358-10" vase	$325–375
359-10" vase (I/95)	$350–400
360-10" vase (I/95)	$300–350
361-12" vase (I/95)	$400–500
362-12" vase (I/95)	$400–500
1068-4" candlestick (pr)	$225–275

*Comprehensive shape list (see page 12)

456-6" jardiniere, brown (I/96)	$400–500
6" vase, dark green (I/96)	$550–650
9" vase, gray (I/96)	$700–800
9" vase, olive green (I/96)	$750–850
9.5" vase, brown (I/96)	$750–850

*CRYSTAL GREEN

2-4.75" bookend (pr)	$200–250
3-4.5" x 5.5" wall shelf (I/97)	$350–450
303-13.5" centerpiece	$225–275
314-14" bowl	$175–225
344-7" basket	$225–275
356-8" basket (I/97)	$325–375
365-6" bowl (I/97/2/2)	$100–125
366-7" bowl	$100–125
367-8" bowl	$125–150
368-10" bowl (I/97)	$150–200
385-10" bowl	$150–200
836-12" vase	$300–400
837-14" vase	$400–500
930-6" vase	$100–125
931-6" vase	$100–125
932-7" vase (I/97)	$150–200
933-7" vase	$150–200
934-8" fan vase (I/97)	$175–225
935-8" vase	$150–200
936-8" vase (I/97)	$150–175
937-9" vase	$175–200
938-9" vase	$175–225
939-10" vase	$225–275
940-10" vase	$200–250
941-10" ewer (I/97)	$175–225
942-8" pillow vase (I/97)	$150–200
943-10" pillow vase	$200–250
1114-2" candlestick (pr)	$150–200
1115-6.5" triple candelabra	$150–175
1116-6.25" quintuple candelabra	$200–225
1122-5.5" candlestick (pr)	$200–250

*Comprehensive shape list (see page 12). However, as noted on page 10, some shapes may be available only as Ivory

867-10.5" vase, Rozane Royal shape,
 blue and green (I/98) $2800-3500
C12-13.25" vase, dark and light blue,
 and gold (I/99) $3500–4500
E58-14.5" basket, reddish orange (I/99) $3000–3500
E64-14.75" vase, blue and green (I/98) $3500–4500
E64-14.75" vase, light and dark gold (I/99) $2500–3000
6.75" ewer, blue, pale gray and gold (I/99) $1200–1500
10.5" vase, green and gold (I/98) $1800–2200

*DAHLROSE

76-6" triple bud vase (I/100)	$150–200
77-7" bud vase (I/100)	$200–250
78-8" bud vase	$200–250
79-6" gate	$225–275
179-8" bowl (I/101/2/1)	$200–250
180-8" bowl	$175–225
209-4" rose bowl (Huxford II/89/2/3)	$150–200
343-5" hanging basket (I/100)	$350–450
343-6" hanging basket (I/100)	$300–350
363-6" vase	$150–175
364-6" vase	$200–250
365-8" vase (I/101/2/4)	$250–300
366-8" vase	$225–275
367-8" vase	$275–350
368-10" vase	$375–450
369-10" vase	$375–450
370-12" vase (I/101)	$650–750
375-10" window box	$300–350
375-14" window box	$400–500
377-12" window box (Huxford II/89/3/2)	$350–400
419-6" vase, square (I/100/1/2)	$300–400
420-10" vase, square (Huxford I/79/2/2)	$500–600
464-9" vase (I/100)	$400–500
496-6" vase (Huxford II/89/1/1)	$150–200
614-6" jardiniere	$175–225
614-7" jardiniere (I/101/2/2)	$250–300
614-8" jardiniere and pedestal	$1200–1400
614-9" jardiniere	$400–500
614-10" jardiniere and pedestal	$1500–1800
614-12" jardiniere	$850–1000
1069-3" candlestick (pr)	$200–250
1258-8" wall pocket	$300–350
1259-10" wall pocket	$375–450
4" vase (I/101/2/3)	$150–200
4" flower pot and saucer (I/101/1/4)	$200–250
5" x 7" pillow vase (Huxford II/89/1/3)	$200–250
6" x 8.25" pillow vase (I/101/1/5)	$225–275
7" bowl (I/101/1/2)	$175–225
8" vase (I/101/1/1)	$300–350
10" vase (I/100/2/1)	$500–600

*Comprehensive shape list (see page 12)

*DAWN

4-5" bookend (pr)	$400–500
31-4" flower frog (I/102)	$125–150
315-4" rose bowl	$150–200
316-6" rose bowl	$175–225
317-10" bowl (I/102)	$175–225
318-14" bowl	$250–300
319-6" centerpiece (I/102)	$350–400
345-8" basket	$300–400
826-6" vase (I/102)	$175–225
827-6" vase (I/102)	$175–225
828-8" bud vase (I/101)	$200–250
829-8" vase (I/101)	$250–300
830-8" vase	$275–350
831-9" vase	$300–400
832-10" vase	$375–450
833-12" vase	$500–600
834-15" ewer	$850–1000
1121-2" candlestick (I/102)	$85–100

*Comprehensive shape list (see page 12)

DECORATED ARTWARE

2-4" teapot, cobalt blue, white stippling,
gilt scroll decals (I/104) — $175–225

6-6.75" teapot, cobalt blue, white slip
decoration, gilt hand-painted lines
and foliage (I/105) — $225–275

10-5" vase, hand-painted roses, cobalt
blue background, Mongol wafer (I/104) — $600–750

15-6" stein, cobalt blue, white stippling,
gilt scroll decals (I/104) — $125–150

409-8" jardiniere, hand-painted pink
roses (I/104/2/1) — $250–300

414-14" jardiniere, lion head handles,
decal of poppies, green and salmon
background (I/105) — $500–600

422-8" jardiniere, hand-painted azaleas
(I/104/2/2) — $250–300

429-8" jardiniere, hand-painted wild roses
(I/105/1/1) — $200–250

886-5" stein, decal of grapes (I/105) — $125–175

DECORATED LANDSCAPE

456-7" jardiniere (I/106) $700–800
456-12" x 42" jardiniere and pedestal (I/106) $5000–6000

DECORATED MATT

468-6" jardiniere, geometrical motifs (I/107) $600–700
724-20.25" umbrella stand, peacock (I/107) $4000–5000
**12" x 42" jardiniere and pedestal, attributed
 to Roseville, 5 colors, conventional
 lotus and leaf motifs, artist initials
 HR (Harry Rhead) (I/107)** $5500–6500

5-8" teapot, conventional floral and foliate motifs, 2 colors, unmarked (I/110) — $2000–2500

8-5.75" teapot, conventional rose and leaf motifs, 2 colors, Rozane Ware wafer (I/109) — $1800–2200

9-10.25" vase, conventional floral bands, 2 colors, Rozane Ware wafer (I/109) — $2000–2500

16-12.75" vase, Japanese-influenced cherry branches, 6 colors, artist signature "H Smith" (Helen Smith), Rozane Ware wafer (I/108) — $4000–5000

34-6.75" pitcher, stylized flowers and leaves, 4 colors, artist initials G.B., no factory mark (I/31) — $4000–5000

43-11.5" vase, ornate Japanese-influenced floral designs, constructed with large fleur-de-lis overlapping a conventional leaf border, 5 colors, artist signature "E Caton" (Ethel Caton), unmarked (I/108) — $7500–8500

51-7" fern dish with handles, alternating Egyptian-style lotus motifs and Japanese-influenced geometrical patterns, 4 colors, artist initials HL (Harry Larzelere), die-impressed 316 (I/108) — $2500–3000

61-20" vase, Pre-Raphaelite woman in garden, 12 colors, artist initials EC (Ethel Caton), professionally restored Rozane Ware wafer reversing an old lamp conversion (I/110) — $35,000–40,000

D17-8" vase, conventional trees on neck, penguins on body, 2 colors, artist initials GA (attributed to Gertrude Andrews), Rozane Ware wafer (I/109) — $2500–3000

*DOGWOOD (SMOOTH)

135-8" vase (I/27/2/3)	$200–250
136-8" vase	$225–275
137-10" vase	$325–375
138-10" vase	$350–400
139-12" vase	$450–550
140-15" vase	$650–750
265-6" basket (I/110)	$200–250
369-12" x 5.75" window box (I/111/1)	$300–400
590-6" jardiniere	$200–250
590-7" jardiniere	$250–300
590-8" jardiniere	$375–450
590-9" jardiniere	$550–650
590-10" jardiniere and pedestal	$1200–1500
590-12" jardiniere and pedestal	$1500–1800
758-21" umbrella stand	$950–1200
1217-15" wall pocket (Huxford II/164/1/2)	$700–800
6" basket (Huxford I/73/1/1)	$175–225
7.75" basket (I/111/3/2)	$250–300
8" basket (Huxford I/73/2/1)	$200–250
8" basket (I/110/2/1)	$225–275
8" basket (I/111/2/1)	$200–250
8" basket (I/111/2/3)	$200–250
9" basket (I/111/2/2)	$225–275
9" basket (I/111/3/1)	$300–400
9" basket (I/111/3/3)	$300–400
5" (?) bowl (Huxford I/73/1/4)	$125–150
8" bud vase (Huxford I/73/2/4)	$175–225
8" double bud vase (I/111)	$200–250
9" bud vase (Huxford I/73/3/2)	$175–225
4" x 7" fern dish (Huxford II/88/3/2)	$150–200
8.75" double wall pocket (Huxford II/164/1/1)	$400–450
10" wall pocket, vase to the right of flowers	$450–550
10.25" wall pocket, vase in center of flowers (Huxford II/168/2/1)	$400–450
8" (?) window box (Huxford I/73/2/2)	$225–275

*Comprehensive shape list (see page 12)

*DOGWOOD (TEXTURED)

150-4" bowl (I/112)	$100–125
150-5" bowl	$125–150
150-6" bowl	$150–175
150-7" bowl	$175–200
151-4" rose bowl (I/113)	$150–175
300-6" vase (I/113)	$200–250
301-7" vase (I/112)	$225–275
302-8" vase	$250–300
303-9" vase	$275–350
304-10" vase	$350–400
305-12" vase (I/112)	$400–500
340-5" hanging basket (I/112)	$300–350
340-6" hanging basket	$350–400
374-10" window box	$300–400
608-5" jardiniere	$175–225
608-6" jardiniere	$200–250
608-7" jardiniere	$250–300
608-8" jardiniere	$350–400
608-9" jardiniere	$400–500
608-10" jardiniere and pedestal	$1200–1500
766-20" umbrella stand	$850–1000
1245-9" wall pocket	$350–400

*Comprehensive shape list (see page 12)

*DONATELLO

NOTE: In the gray/brown coloring, add 25%.

1 jewel box (covered)	$375–450
2 jewel box (covered)	$300–400
8 gate	$100–125
9 gate	$125–150
9-9" compote	$250–300
14-2.5" flower block	$40–50
14-3.5" flower block	$50–60
15 ashtray	$125–150
16 ashtray	$150–175
17 ashtray	$125–150
36-10" bud vase	$175–200
53-6" bowl	$125–150
53-7" bowl	$150–175
54-8" bowl	$175–200
55-10" bowl	$200–225
60-6" bowl	$125–150
60-8" bowl	$150–175
60-10" bowl	$175–200
60-12" bowl	$200–225
61-6" low bowl	$225–275
61-8" low bowl	$250–300
61-10" low bowl	$300–350
88 rose bowl	$200–250
89 bowl	$125–150
90 bowl	$150–175
91 bowl	$150–175
92 bowl	$175–200
101-8" vase	$200–250
102-8" vase	$200–250
103-8" vase	$200–250
104-8" vase (l/113)	$200–250
105-10" vase (l/115)	$225–275
106-10" vase	$225–275
107-10" vase	$225–275
108-10" vase	$225–275
109-12" vase	$275–350
110-12" vase	$275–350
111-12" vase (l/113)	$275–350
112-12" vase	$275–350
113-7" vase	$175–200
113-8" vase	$200–225
113-10" vase	$225–250
113-12" vase	$275–350
113-15" vase	$550–650
114-7" bud vase	$150–175
115-10" bud vase (l/113)	$175–225
116-6" vase	$150–175
118-6" vase	$125–150
118-8" vase	$150–175
184-6" vase	$175–200
184-8" vase	$200–225
184-10" vase	$225–250
184-12" vase	$250–300

Item	Price
192-6" bowl	$250-300
227-4" fern dish	$100-125
227-5" fern dish	$125-150
227-6" fern dish	$150-175
228-6" x 6" footed fern dish	$225-275
229-9" x 4" footed fern dish	$200-250
230-7" x 3" footed fern dish (I/113/2/4)	$175-225
231-4" x 3" footed fern dish	$125-150
231-5" footed fern dish	$150-175
231-6" footed fern dish	$175-200
232-8" footed fern dish	$225-275
233-5" basket	$175-225
233-6" basket	$200-250
233-7" basket	$225-275
233-8" basket	$250-300
237-7" combination fern dish and bud vase	$275-350
238-5" fern dish	$125-150
238-6" fern dish	$150-175
238-7" fern dish	$175-200
301-9" basket	$300-350
302-10.5" basket	$400-500
303-11" basket (I/115)	$500-600
304-12" basket	$500-600
305-14" basket	$600-700
306-14" basket	$600-700
327-6" hanging basket	$325-375
327-8" hanging basket	$275-325
364-10" x 4.5" window box (I/114)	$250-300
364-14" x 5" window box (I/115)	$300-400
415-8" vase	$300-400
417-10" vase	$550-650
575-4" jardiniere	$125-150
575-5" jardiniere	$150-175
575-6" jardiniere	$200-250
575-6" x 18" jardiniere and pedestal	$600-700
575-7" jardiniere	$250-300
575-8" jardiniere	$300-350
575-8" x 24" jardiniere and pedestal	$800-900
575-9" jardiniere	$350-400
575-10" jardiniere	$400-450
575-10" x 28" jardiniere and pedestal	$1000-1200
579-6" jardiniere	$200-250
579-8" jardiniere	$300-350
579-10" jardiniere	$400-450
579-10" x 28" jardiniere and pedestal	$1000-1200
579-12" jardiniere	$500-600
579-12" x 34" jardiniere and pedestal	$1200-1500
580-4" flower pot and saucer	$200-250
580-5" flower pot and saucer	$225-275
580-6" flower pot and saucer	$250-300
628-5.5" cuspidor	$350-400
753-21" x 10" umbrella stand	$750-950
1008-7.5" candlestick (pr)	$350-400
1009-6" bedside candlestick	$175-225

*DONATELLO *(cont.)*

1011 bedside candlestick	$125–150
1022-10" candlestick (pr)	$400–500
1212-10" wall pocket (misprinted as shape 1202 in stock page)	$275–350
1212-12" wall pocket	$350–425
1307 pitcher	$400–500
6" vase (Huxford II/78/1/2)	$275–350
5.75" basket, ring handle (I/113/2/1)	$225–275
8.5" basket (I/113/2/1)	$325–375
7" double bud vase, satyr (Huxford II/78/1/3)	$350–400
ashtray (Huxford II/79/1/5)	$150–175
3.25" x 3.75" incense burner, covered	$350–400
3" vase, flower pot shape (I/115/1/3)	$75–100
flower frog, T-shaped, for 3" vase, flower pot shape	$25–30
12.5" vase, elongated handles (I/115/1/2)	$700–800

*Comprehensive shape list (see page 12)

15-2.5" flower block	$100–125
15-3.5" flower block	$100–125
88-10" fan vase	$400–450
89-8" fan vase	$350–400
90-8" crocus pot	$850–1000
91-8" strawberry jar, separate saucer	$1200–1500
92-9" strawberry jar	$1200–1500
217-4" bowl	$325–375
218-9" bowl	$300–350
347-6" hanging basket, strawberry jar shape	$1500–1800
515-4" vase	$250–300
516-4.5" vase (I/116)	$275–325
517-5.5" vase (I/116)	$300–350
518-6" vase	$300–350
519-7" vase (I/116)	$350–400
520-8" vase	$400–500
521-7" vase (I/116)	$400–500
522-9" vase	$550–650
741-20" umbrella stand, Antique Matt Green shape (Huxford II/174/1/2)	$2000–2500
769-14" x 11.5" sand jar	$1500–1800
1059-3" candlestick, Carnelian shape (pr)	$250–300
1080-4" bedside candlestick	$375–450
1081-4" candlestick (I/116) (pr)	$300–350
1263 wall pocket	$850–1000

*Comprehensive shape list (see page 12)

EARLY CARNELIAN

Note: Add 25% for mottled matte green.

15-3.5" flower block (I/117)	$20–25
16 gate	$125–150
33-6" vase	$85–100
34-8" vase	$125–150
35-10" vase (I/119)	$125–150
36-6" bud vase (I/117)	$75–100
37-5" vase	$100–125
38-5" vase	$100–125
39-6" vase	$100–125
40-6" vase	$100–125
41-6" vase (I/119)	$100–125
42-6" bud vase	$85–100
43-8" vase	$125–150
44-8" vase (I/119)	$125–150
45-8" vase (I/117)	$125–175
46-8" vase (I/117)	$150–200
66-7" bowl, round (I/117/2)	$75–100
234-5" basket	$125–150
234-6" basket	$125–150
234-7" basket (I/117)	$175–225
234-8" basket	$200–250
236-8" combination fern dish and bud vase	$225–275
581-10" jardiniere (I/35)	$400–500
582-6" flower pot and separate saucer	$125–175
583-9" jardiniere (I/119)	$375–450
742-27" umbrella stand (I/119)	$950–1200
1012-5" candlestick (pr)	$125–150
1013-7" candlestick (pr)	$150–175
1014-9" candlestick (pr)	$175–225
7.5" bowl, footed (I/119)	$60–70
3.75" x 5" incense burner	$125–150
8" vase (I/11)	$125–150

*EARLY ROSECRAFT

14-8" compote (I/120)	$175–225
115-5" bowl (I/120)	$125–150
115-6" bowl	$150–175
115-7" bowl	$175–200
116-5" bowl	$125–150
116-6" bowl	$150–175
117-6" bowl	$150–175
118-6" bowl	$150–175
193-5" vase (I/120)	$175–225
194-6" vase (I/120)	$225–250
195-6" vase (I/120)	$175–225
196-6" vase	$200–225
197-8" vase (I/120)	$275–325
198-8" vase	$275–325
199-8" vase (I/120)	$275–325
200-8" vase	$275–325
201-10" vase	$350–400
202-10" vase	$325–375
203-10" vase (I/120)	$325–375
204-10" vase (I/120)	$350–400
205-12" vase	$400–500
254-6" fern dish (I/120)	$150–200
335-6" hanging basket	$300–400
600-5" jardiniere	$200–225
600-6" jardiniere	$225–250
600-7" jardiniere	$275–350
600-8" jardiniere	$350–400
600-9" jardiniere	$400–500
600-10" jardiniere and pedestal	$1200–1500
1044-8" candlestick (I/120)	$150–200
1045-10" candlestick (I/120)	$175–225
1226-11" wall pocket	$350–400
1227-12" wall pocket	$500–600

*Comprehensive shape list (see page 12)

EARLY VELMOSS

For hand-applied glazes, add 25%.

Early Carnelian 15-3.5" flower block (I/121)	$20–25
55-10" bowl (I/121/2/2)	$200–250
125-6" vase (I/122/3)	$400–500
126-6" vase (I/121/2/3)	$400–500
138-12" vase (cover)	$850–1000
577-10" x 27" jardiniere and pedestal (I/121)	$2500–3000
8" vase (I/122/1)	$600–700
8" vase (I/121/2/1)	$500–600
10" vase (I/122/2/1)	$750–850
10" vase (I/122/2/2)	$750–850

E17-6" vase, cherries and pears, semigloss pea green, Egypto wafer (I/124) — $500–600

E35-5.25" oil lamp, semigloss dark green, Egypto wafer (I/124) — $650–750

E44-6" vase, geometrical motifs, matte medium green with veining, Egypto wafer (I/124) — $700–800

E58-14.5" basket, geometrical motifs, matte light and medium green, strong organic texture, Egypto wafer (I/123) — $1200–1500

E60-3.75" candlestick, "More Light" quotation from Goethe, matte bright green, dark peppering, Egypto wafer (I/123) — $375–450

E68-16.25" vase, birds roosting in tree, matte light and medium green, somewhat organic texture, Egypto wafer (I/124) — $1800–2200

3.25" x 5" inkwell, Greek columns alternating with legalistic, patriotic and Christian motifs, laurel wreath on shoulder, white lining, semigloss bright green, Egypto wafer (I/124) — $500–600

10" vase (derived from shape E48), bottle shape, matte light and medium green, strong organic texture, Egypto wafer (I/124) — $750–950

EXPERIMENTAL PIECES

8" vase, Amaryllis, pink and green (I/25)	$3000–3500
10" vase, Dahlia, pink and green (I/26)	$2500–3000
9" vase, Freesia, green and tan (I/26)	$2500–3000
10" vase, Silhouette nude, rust (I/26)	$2000–2500
8" vase, ribbed, Carnelian (Drip) colors (I/26)	$2000–2500
8" vase, floral vine at neck, fluting (similar to Savona), brown, ivory, green and pink (I/26)	$2500–3000
12.25" vase, floral tree at shoulder, shape reminiscent of Victorian Art Pottery and glaze of Panel, medium and dark brown, rust flowers (I/26)	$3000–3500

*FALLINE

	Blue	Brown
244-8" bowl (I/125)	$700–800	$500–600
642-6" vase (I/125)	$800–900	$550–650
643-6" vase (I/126)	$750–850	$500–600
644-6" vase (I/126)	$950–1200	$600–700
645-6.5" vase (I/125)	$950–1200	$600–700
646-8" vase	$1200–1500	$800–900
647-7" vase	$950–1200	$700–800
648-7" vase (I/125)	$950–1200	$700–800
649-8" vase (I/125)	$1200–1500	$950–1200
650-6" vase	$950–1200	$700–800
651-8" vase (I/125)	$1500–2000	$1200–1500
652-9" vase (I/125)	$1500–2000	$1200–1500
653-12" vase	$2500–3000	$1800–2200
654-13.5" vase	$3000–3500	$2500–3000
655-15" vase (I/125)	$3000–3500	$2500–3000
1092-3.5" candlestick (pr)	$850–1000	$700–800

*Comprehensive shape list (see page 12)

*FERELLA

	Red	Brown
15-2.5" flower block	$85–100	$75–85
15-3.5" flower block	$100–125	$85–100
87-8" bowl with attached flower frog	$850–950	$700–800
210-4" footed bowl	$475–550	$375–450
211-8" bowl	$750–850	$650–750
212-12" x 7" bowl	$850–950	$750–850
497-4" vase (I/127)	$400–500	$350–425
498-4" vase	$400–500	$350–425
499-6" vase	$500–600	$450–500
500-5" vase (I/127)	$600–700	$500–600
501-6" vase (I/127)	$800–900	$600–700
502-6" vase	$800–900	$600–700
503-5" vase	$600–700	$500–600
504-5.5" vase (I/127)	$600–700	$500–600
505-6" vase (I/127)	$700–800	$600–700
506-8" vase (I/127)	$850–1000	$700–800
507-9" vase (I/127)	$950–1200	$800–900
508-8" vase	$950–1200	$800–900
509-8" vase (I/127)	$950–1200	$800–900
510-9" vase	$1000–1200	$800–900
511-10" vase (I/127)	$1400–1600	$1000–1200
620-5" flower pot (I/9)	$1000–1200	$850–1000
1078-4" candlestick (pr)	$750–850	$600–700
1266-6.5" wall pocket (I/127)	$1500–1800	$1200–1500

*Comprehensive shape list (see page 12)

*FLORANE

50-8" jardiniere	$100–125
51-10" jardiniere (l/128)	$150–200
52-12" jardiniere	$175–225
60-6" bowl	$75–85
61-9" planter	$75–100
62-8" bowl	$75–100
63-10" bowl	$85–100
64-12" bowl	$100–125
71-4" vase (l/128)	$60–75
72-5" vase	$75–85
73-6" vase	$85–100
79-7" bud vase	$75–85
80-6" vase (l/128)	$60–75
81-7" vase (l/128)	$75–100
82-9" vase	$125–150
83-11" vase	$150–175
84-14" vase	$175–250
90-4" planter (l/129)	$60–75
91-6" window box	$60–75
92-6" planter (l/128)	$60–75
93-7" bowl, square	$60–75
94-8" window box	$75–100
95-10" bowl, rectangular	$60–75
96-10" window box (l/129)	$75–100

*Comprehensive shape list (see page 12)

*FLORENTINE

6-4" compote (I/130)	$125–150
7 compote	$325–375
15-2.5" flower block	$40–50
15-3.5" flower block	$50–60
17-3" ashtray (I/130)	$100–125
17-8" compote	$225–275
40-4.5" gate	$125–175
41-6" gate	$150–200
125-4" bowl (I/130)	$75–100
125-5" bowl	$100–125
125-6" bowl	$125–150
125-7" bowl	$150–175
126-4" bowl	$75–100
126-5" bowl	$100–125
126-6" bowl	$125–150
126-7" bowl	$150–175
130-4" rose bowl	$125–150
228-6" vase	$125–150
229-6" vase (I/130)	$125–175
230-8" vase	$175–225
231-8" vase (I/130)	$250–300
232-10" vase (I/130)	$275–325
233-10" vase (I/2)	$250–300
234-12" vase (I/130)	$325–375
252-6" vase	$125–175
253-6" vase (I/130)	$125–175
254-7" vase	$150–200
255-8" vase (I/130)	$200–250
257-5" fern dish	$125–150
257-6" fern dish	$150–175
258-5" fern dish	$175–200
258-6" fern dish	$200–225
297-14.5" sand jar (Huxford I/147/1/4)	$400–500
298-18.5" umbrella stand (I/130)	$600–700
299-14" sand jar	$400–500
320-6" basket	$175–225
321-7" basket	$225–275
322-8" basket	$275–350
337-6" hanging basket	$175–225
337-7" hanging basket	$275–325
339-5" hanging basket	$250–300
371-11.5" window box (Huxford II/91/4/2)	$250–300
602-5" jardiniere	$125–150
602-5" jardiniere, version without handles	$125–175
602-6" jardiniere	$150–175
602-6" jardiniere, version without handles (I/129/2/1)	$150–200
602-7" jardiniere	$200–250
602-8" jardiniere	$300–350
602-9" jardiniere	$400–450
602-9" jardiniere and pedestal	$1000–1200
602-9" jardiniere and pedestal, version without handles	$1000–1400

*FLORENTINE *(cont.)*

602-10" jardiniere and pedestal	$1200–1500
763-20" umbrella stand	$750–850
764-14" x 11" sand jar	$500–600
1049-8" candlestick (I/130)	$125–150
1050-10" candlestick (I/130)	$150–175
1062-4" candlestick (pr)	$150–200
1230-10" wall pocket	$375–450
1231-12" wall pocket	$450–500
1238-7" wall pocket	$250–300
1238-8" wall pocket	$325–375
1239-7" wall pocket	$300–350

*Comprehensive shape list (see page 12)

*FOXGLOVE

2-10" compote	$225–275
4-6.5" ewer	$200–250
5-10" ewer	$300–375
6-15" ewer	$850–1000
10-5.5" bookend (I/7) (pr)	$275–325
42-4" vase	$100–125
43-6" vase	$125–150
44-6" vase (I/131)	$150–175
45-7" vase (I/131)	$175–200
46 flower frog	$125–175
46-7" vase	$200–225
47-8" vase (I/131)	$200–250
48-8" vase	$225–250
49-9" vase	$250–300
50-9" vase	$275–325
51-10" vase	$300–350
52-12" vase	$350–400
53-14" vase (I/131)	$700–800
54-15" vase	$800–900
55-16" vase (I/132)	$850–1000
56-18″ vase (I/132)	$1200–1400
159-5" bud vase	$125–175
160-4.5" gate	$150–200
161-6" vase (I/131)	$150–175
162-8" vase	$175–225
163-6" cornucopia	$125–150
164-8" cornucopia	$175–200
165-5" flower holder	$150–200
166-6" cornucopia	$150–200
373-8" basket (I/131)	$300–400
374-10" basket (I/131)	$400–500
375-12" basket (I/131)	$550–650
418-4" rose bowl	$150–175
418-6" rose bowl	$200–250
419-6" tray	$150–175
420-10" tray	$175–200
421-10" bowl	$200–250
422-10" bowl	$175–225
423-12" bowl	$275–325
424-14" tray	$225–275
425-14" bowl	$325–375
426-6" conch shell	$175–225
466-5" hanging basket	$350–400
659-3" jardiniere	$100–125
659-4" jardiniere	$125–150
659-5" jardiniere	$150–200
659-6" jardiniere	$200–250
659-8" jardiniere and pedestal	$1200–1500
659-10" jardiniere and pedestal	$1500–1800
660-5" flower pot and saucer	$175–225
1149 candlestick (pr)	$150–200
1150-4.5" candlestick (pr)	$200–250
1292-8" wall pocket	$450–550

*Comprehensive shape list (see page 12)

4-8" cookie jar (l/8)	$450–500
6-C creamer	$75–100
6-S sugar bowl	$75–100
6-T teapot	$325–375
7-10" compote (l/12)	$200–250
15 bookend (pr)	$300–350
19-6" ewer	$175–225
20-10" ewer	$275–350
21-15" ewer	$850–1000
117-6" vase	$125–175
118-6" vase (l/133)	$125–175
119-7" vase (l/133)	$125–175
120-7" vase	$125–175
121-8" vase (l/133)	$175–225
122-8" vase	$175–225
123-9" vase (l/133)	$225–275
124-9" vase	$200–250
125-10" vase	$200–250
126-10" vase (l/133)	$200–250
127-12" vase	$250–350
128-15" vase (l/133)	$800–900
129-18" vase (l/8)	$950–1200
195-7" bud vase	$150–175
196-8" vase	$225–275
197-6" cornucopia	$100–125
198-8" cornucopia (l/12)	$125–150
199-6" fan vase (l/133)	$125–175
200-7" fan vase (l/133)	$125–175
390-7" basket (l/133)	$175–225
391-8" basket	$225–275
392-10" basket	$275–350
463-5" rose bowl	$150–200
464-6" bowl (l/12)	$100–125
465-8" bowl	$150–200
466-10" bowl	$175–225
467-10" bowl	$175–225
468-12" bowl	$200–250
469-14" bowl	$225–275
471-5" hanging basket	$250–325
669-4" jardiniere	$125–150
669-6" jardiniere	$125–150
669-8" jardiniere and pedestal	$1200–1400
670-5" flower pot and saucer (l/133)	$175–225
1160-2" candlestick (l/12) (pr)	$100–125
1161-4.5" candlestick (pr)	$150–200
1296-8" wall pocket	$350–400
1392-8" window box	$150–200

*Comprehensive shape list (see page 12)

*FUCHSIA

37 flower frog	$175–225
129-6" cornucopia	$150–200
346-4" rose bowl	$175–225
347-6" rose bowl	$250–300
348-5" bowl	$150–200
349-8" bowl	$200–250
350-8" bowl	$250–300
350-8" basket, built-in flower frog	$450–550
351-10" basket	$550–650
351-10" bowl	$275–350
352-12" bowl	$350–400
353-14" bowl	$400–450
359-5" hanging basket	$375–450
645-3" jardiniere (I/134)	$125–175
645-4" jardiniere (I/134)	$175–225
645-5" jardiniere	$200–250
645-6" jardiniere	$250–300
645-8" jardiniere and pedestal	$1500–1800
645-10" jardiniere and pedestal	$1800–2200
646-5" flower pot and saucer	$400–500
891-6" vase	$175–225
892-6" vase	$175–225
893-6" vase	$175–225
894-7" vase (I/134)	$200–250
895-7" vase (I/134)	$200–250
896-8" pillow vase	$275–350
897-8" vase	$275–350
898-8" vase	$275–350
899-9" vase (I/134)	$350–400
900-9" vase (I/134)	$350–400
901-10" vase	$400–500
902-10" ewer (I/134)	$375–450
903-12" vase	$600–700
904-15" vase	$1000–1200
905-18" floor vase	$1200–1500
1132-candlestick (pr)	$200–250
1133-5" candlestick (pr)	$400–500
1282-8" wall pocket	$700–800
1322-8" ice-lip pitcher (I/135)	$600–700

*Comprehensive shape list (see page 12)

961-10.5" vase, gold and brown, artist
 monogram EN or NE (I/135) $2000–2500

961-10.5" vase, gold, navy blue and teal,
 artist monogram EN or NE (I/135) $1800–2200

970-10" bud vase, brown and teal, artist
 monogram SG or GS, Rozane
 Ware wafer (I/32/1/3) $2500–3000

971-9" vase, gold, navy blue and teal, artist
 monogram SG or GS, Rozane Ware
 wafer (I/135) $1500–1800

972-8" vase, gold, brown, navy blue and
 teal, Rozane Ware wafer (I/136) $1500–1800

R5-10.25" vase, gold, navy blue and teal,
 Rozane Ware wafer (I/136) $1800–2200

R6-8.25" vase, brown, navy blue and teal,
 unmarked (I/136) $1500–1800

FUJIYAMA

969-12" vase, orchid, Fujiyama
 inkstamp (I/136) $1800–2200
980-5.75" vase, tulip, Fujiyama
 inkstamp (I/136) $1200–1500

15-2.5" flower block ("Little Round Frog") $125–150
15-3.5" flower block ("Big Round Frog") green, $175–200
 brown, $150–175
81-5" x 1.5" x 5" pillow vase ("Blue Sunray") $500–600
82-6" fan vase ("Blue Fan") $400–500
85-4" pillow vase ("2-Pole Pink Pillow
 Vase," I/138) $375–450
187-8" bowl ("Balloons Bowl") $400–500
188-8" bowl ("Aztec Bowl") pink, $1500–1800
 brown, $600–700
189-4" x 6" footed bowl ("Sand Toy") $600–700
190-3.5" x 6" bowl ("Blue Box") $400–450
191-8" bowl ("Square Box") $500–600
194-5" bowl ("Little Flying Saucer," or
 "Ashtray") $1500–2000
195-10" bowl ("Flying Saucer") $1000–1200
196-12" x 5" x 3.5" bowl with separate
 flower frog ("Sailboat") $600–700
197-6" footed bowl ("Half-Egg," I/282) $600–700
198-5" footed bowl ("Hibachi") $1000–1200
344-5" hanging basket ("Little Hanging
 Basket") gray, $500–600
 brown, $400–500
344-6" hanging basket ("Big Hanging
 Basket") gray, $600–700
 brown, $500–600
376-15" x 4" x 6" window box
 ("Window Box," I/11) $1800–2200
380-6" vase ("Torch") $500–600
381-6" vase ("Beer Mug") $400–500
382-7" vase ("Telescope," I/138) $450–550
383-8" vase ("Little Blue Triangle") $550–650
384-8" vase ("Ball Bottle," I/138) $550–650
385-8" vase ("Pleated Star," I/138) $500–600
386-8" vase ("Jukebox") brown, $1200–1500
 pink and green, $750–850
387-7" vase ("Bamboo Leaf Ball") $900–1200
388-9" vase ("Big Blue Triangle") $700–800
389-9" vase ("Emerald Urn," I/138) bluish green, $900–1200
 Savona green, $700–800
390-10" bud vase ("Christmas Tree") dark blue, $850–1000
 brown, $750–850
391-10" vase ("Black Flame") $1000–1200
392-10" vase ("Shooting Star") $850–1000
393-12" vase ("Four Ball Vase," I/20) $1200–1400
394-12" vase ("Bomb") $1200–1400
395-10" vase ("Stepped Urn") $1000-–1200
396-5.5" vase ("Chalice") $1800–2200
397-6" vase ("Square Cone") $400–500
398-6.5" vase ("Green Twist") $500–600
399-7" vase ("Red Vee") $600–700
400-7" vase ("Ostrich Egg," I/137) $600–700
401-8" vase ("Cone," I/138) $700–800
402-8" vase ("Milk Carton," I/138) $600–700
403-7" vase ("Spittoon," I/137) $800–900

*FUTURA *(cont.)*

404-8" vase ("Balloons Globe")	blue, $1500–1800
	green, $1200–1500
405-7.5" vase ("Spaceship")	$750–850
406-8" vase ("Beehive")	$800–900
407-9" vase ("Green Fan")	$1500–1800
408-10" vase ("Seagull," I/138)	$1000–1200
409-9" vase ("Football Urn")	$1000–1200
410-12" vase ("Table Leg")	$1500–1800
411-14" vase ("Arches")	$2800–3200
412-9" vase ("Tank")	$8500–10,000
421-5" vase ("Brown Stump")	$350–450
422-6" bud vase ("Two-Pole Bud Vase")	$400–500
423-6" pillow vase ("Tombstone," I/138)	$450–550
424-7" vase ("Stepped Egg")	$650–750
425-8" vase ("Hexagon Twist")	$650–750
426-8" vase ("Winged Vase")	$1200–1500
427-8" vase ("Mauve Thistle," I/36)	$850–1000
428-8" vase ("Egg with Leaves")	$700–800
429-9" vase ("Purple Crocus," I/138)	$1000–1200
430-9" vase ("Chinese Pillow")	$1000–1200
431-10" vase ("Falling Bullet")	$850–1000
432-10" vase ("Space Capsule")	$1000–1200
433-10" vase ("Pine Cone," I/36)	$1000–1200
434-10" vase ("Michelin Man")	$4000–5000
435-10" vase ("Elephant Leg," I/33/3/2)	$1500–1800
436-12" vase ("Chinese Bronze")	$5000–6000
437-12" vase ("Weeping Tulip," I/36)	$1500–1800
438-15" vase ("Tall Teasel")	$2500–3000
616-6" jardiniere (I/138)	gray, $450–500
	brown, $400–500
616-7" jardiniere	gray, $500–550
	brown, $450–500
616-8" jardiniere	gray, $700–800
	brown, $600–700
616-9" jardiniere (I/138)	gray, $850–1000
	brown, $700–800
616-10" jardiniere and pedestal	gray, $2500–3000
	brown, $2000–2500
1072-4" candlestick ("Aztec Ladies") (pr)	$850–1000
1073-4" candlestick ("Candlesticks with Leaves") (pr)	$550–650
1075-4" candlestick ("Flying Saucer Candlesticks") (pr)	$1000–1200
1261-8" wall pocket	$700–800

*Comprehensive shape list (see page 12)

GARDEN POTTERY

NOTE: No examples have been located, and no pricing information is available. For shape numbers, see *Introducing Roseville Pottery.*

*GARDENIA

600-4" jardiniere	$100–125
601-6" jardiniere	$150–175
603-10" jardiniere and 609-10" pedestal	$1200–1500
605-8" jardiniere and pedestal	$1000–1200
608-8" basket	$200–250
609-10" basket	$250–300
610-12" basket	$350–450
616-6" ewer	$150–175
617-10" ewer	$200–250
618-15" ewer (I/8)	$600–700
621-6" cornucopia	$125–150
622-8" double cornucopia	$150–200
626-6" bowl (I/139)	$100–125
627-8" bowl	$125–150
628-10" bowl	$150–175
629-10" bowl	$150–175
630-12" bowl (I/140)	$175–225
631-14" tray	$150–200
632-14" bowl	$250–300
641-5" rose bowl	$125–175
651-2" candlestick (I/139) (pr)	$100–125
652-4.5" candlestick (pr)	$125–175
656-3" planter (I/140)	$75–100
657-3.5" rose bowl (I/140)	$75–100
658-8" window box	$175–225
659 bookend (pr)	$250–300
661-5" hanging basket	$275–325
666-8" wall pocket	$250–300
668-8" window box	$100–125
669-12" window box	$275–325
681-6" vase (I/140)	$100–125
682-6" vase (I/140)	$100–125
683-8" vase (I/139)	$150–200
684-8" vase (I/140)	$125–150
685-10" vase (I/139)	$175–225
686-10" vase	$175–225
687-12" vase	$250–300
688-12" vase	$250–300
689-14" vase	$550–650
690-16" vase	$700–800

*Comprehensive shape list (see page 12)

*HEXAGON

NOTE: Add 25-50% for blue.

8-7" vase	$350–450
47-5" gate	$225–275
134-4" bowl (I/141)	$225–275
135-4" bowl	$225–275
136-5" bowl	$200–250
137-6" bowl	$225–275
138-4" rose bowl	$250–300
266-4" vase	$225–275
267-5" vase (I/141)	$275–325
268-6" vase (I/141)	$300–400
269-6" vase (I/141)	$300–350
270-8" vase	$450–550
271-8" vase (I/141)	$400–500
272-10" vase (I/140)	$650–750
1240-8" wall pocket	$600–700
8" candlestick	$225–275

*Comprehensive shape list (see page 12)

*IMPERIAL (GLAZES)

20 ashtray	$375–450
199-4.5" bowl	$300–350
200-4.5" bowl (I/34)	$300–350
201-4" bowl (I/142)	$325–375
202-6" bowl (I/142)	$1500–1800
203-5" bowl	$350–400
204-8" bowl	$350–400
205-8" bowl	$375–425
206-8" bowl (I/142)	$500–600
207-12" x 8" bowl	$400–500
466-4" vase	$400–500
467-5" vase	$275–325
468-5" vase (I/142)	$275–325
469-6" vase	$325–375
470-5.5" vase	$450–550
471-7" vase (I/142)	$500–600
472-7" vase	$350–400
473-7.5" vase	$700–800
474-7" vase	$850–1000
475-9" vase	$1000–1200
476-8" vase	$750–850
477-9.5" vase (I/142)	$1000–1200
478-8" vase (I/142)	$700–800
479-8" vase (I/142)	$600–700
480-8" vase	$4000–5000
481-8.5" vase (I/142)	$700–800
482-11" vase (I/142)	$1000–1200
483-10" vase	$850–1000
484-11" vase (I/142)	$1500–1800
1076-2.5" candlestick (pr)	$250–300
1077-4" candlestick (pr)	$275–325
1262 wall pocket	$850–950
1263 wall pocket	$800–900
1264 wall pocket	$650–750
9.5" ashtray (I/142/2/3)	$450–550

*Comprehensive shape list (see page 12)

*IMPERIAL (TEXTURED)

29-8" triple bud vase (I/144)	$175–225
30-8.5" triple bud vase	$200–250
31-9" bud vase	$150–200
71-7" bowl	$125–150
71-8" bowl (I/144)	$125–150
150-8" vase	$200–250
151-8" vase	$200–250
152-8" vase	$250–300
156-12" vase	$400–500
162-18" floor vase	$650–750
163-18" floor vase	$750–850
251-6" fern dish	$150–175
251-7" fern dish	$175–200
252-7" footed fern dish	$175–200
291-7" basket (I/143)	$175–225
333-6" hanging basket	$275–325
333-7" hanging basket	$300–350
370-10" window box	$250–300
370-12" window box	$275–325
591-6" jardiniere	$125–175
591-7" jardiniere	$175–225
591-8" jardiniere	$300–350
591-9" jardiniere	$400–500
591-10" jardiniere	$500–600
591-10" jardiniere and pedestal	$1000–1200
591-12" jardiniere	$600–700
759-20" umbrella stand	$850–1000
1221-7" wall pocket	$275–325
1222-9" wall pocket	$350–400
1223-10" wall pocket	$375–425
6" basket (Huxford I/57/1/1)	$175–225
6" basket (Huxford I/57/1/2)	$175–225
6" basket (Huxford I/57/1/6)	$175–225
8" basket (I/143/2/1)	$225–275
9" basket (Huxford II/77/1/1)	$250–300
10" basket (Huxford II/77/1/2)	$275–325
10" basket (Huxford II/77/1/3)	$250–300
10.75" basket (I/144/1/2)	$250–300
12.25" basket (I/143/1/1)	$350–450
12.5" basket (I/143/2/2)	$300–400
10" vase (Huxford I/57/2/2)	$350–450
10" vase (Huxford II/77/2/1)	$350–450
10" vase (Huxford II/77/3/1)	$300–400
12" vase (I/143/1/3))	$400–500
14" floor vase (I/143/1/2)	$500–600
16" floor vase	$600–700

*Comprehensive shape list (see page 12)

*IRIS

2 wall shelf	$450–550
5 bookend (pr)	$350–450
38 flower frog (I/8)	$150–175
130-4" vase (I/145)	$125–150
131-6" cornucopia (I/20)	$150–175
132-8" cornucopia	$175–200
354-8" basket (I/145)	$350–450
355-10" basket	$500–600
357-4" rose bowl	$175–225
358-6" rose bowl	$200–250
359-5" bowl	$150–175
360-5" hanging basket	$375–450
360-6" bowl	$175–200
361-8" bowl	$200–250
362-10" bowl	$225–275
363-12" bowl	$250–300
364-14" bowl	$275–325
647-3" jardiniere	$125–150
647-4" jardiniere	$150–175
647-5" jardiniere	$250–300
647-6" jardiniere	$300–350
647-8" jardiniere and pedestal	$1200–1500
647-10" jardiniere and pedestal	$1800–2200
648-5" flower pot and saucer	$275–325
914-4" vase (I/144)	$125–150
915-5" vase	$150–175
916-6" vase (I/144)	$175–200
917-6" vase (I/145)	$175–200
918-7" bud vase (I/20)	$175–225
919-7" vase (I/144)	$200–250
920-7" vase	$200–250
921-8" vase	$250–300
922-8" pillow vase	$275–350
923-8" vase	$250–300
924-9" vase (I/144)	$375–450
925-9" vase	$375–450
926-10" ewer (I/144)	$450–550
927-10" vase (I/144)	$400–500
928-12" vase	$600–700
929-15" vase (I/145)	$1000–1200
1134 candlestick (pr)	$250–300
1135-4.5" candlestick (pr)	$300–350
1284-8" wall pocket	$700–800

*Comprehensive shape list (see page 12)

1-6.5" dog (I/148)	$500–600
2-4.75" bookend, Crystal Green shape (pr)	$175–225
3-4.5" x 5.5" wall shelf, Crystal Green shape	$175–225
12-8" x 4.5" compote, Volpato shape **(I/34)**	$125–150
17-3" ashtray, Florentine shape	$75–85
24-3.5" shell ashtray	$50–60
28-9" lady flower frog (I/148)	$1000–1200
103-6" covered jar	$150–200
105-8" vase, also a Tourmaline shape	$125–175
106-7" cornucopia, also a Tourmaline shape	$75–85
111 triple cornucopia, Russco shape **(I/148)**	blue lined, $200–250
	ivory, $125–150
115-7" vase, Velmoss shape **(I/147)**	$75–100
115-10" vase, Donatello shape	$150–200
126-6" cornucopia, Pine Cone shape	$100–125
158-5" rose bowl, Rosecraft shape **(I/147)**	$100–125
196-12" x 5" x 3.5" bowl, Futura shape	$150–200
207-8" x 12" bowl, Imperial (Glazes) shape	$175–225
209-10" vase, Volpato shape	$125–175
222-12" vase, Savona shape	$150–200
236-3" bowl, Solid Colors shape **(I/148)**	$75–100
238-5" rose bowl, also a Tourmaline shape	$100–125
249-12" bowl, Topeo shape	$150–200
267-6" x 12" bowl	$150–200
277-12" x 8" bowl	$125–150
301-10" bowl, Moderne shape	$125–175
302-14" bowl, Moderne shape **(I/148)**	$150–175
315-4" rose bowl, Dawn shape	$100–125
316-10" vase, Carnelian/Rosecraft shape	$150–200
317-10" vase, Carnelian/Rosecraft shape	$150–200
327-8" hanging basket, Donatello shape	$150–175
337-10" basket, Russco shape	$150–175
341-5" vase, Tuscany shape	$75–100
344-7" basket, Crystal Green shape **(I/148)**	$125–150
345-8" basket, Dawn shape **(I/147)**	$125–150
345-8" vase, Tuscany shape	$100–125
346-9" vase, Tuscany shape **(I/148)**	$100–125
356-8" basket, Crystal Green shape	$125–150
371-6" vase, Savona shape **(I/148)**	$75–100
374-8" vase, Savona shape	$100–125
378-3.5" x 10" window box (I/147)	$150–175
435-10" vase, Futura shape	$400–500
467-5" vase, Imperial (Glazes) shape	$100–125
548-4" flower pot, Matt Green shape	$35–45
549-4" flower pot, Matt Green shape	$35–45
550-4" jardiniere, Antique Matt Green shape	$35–45
575-4" jardiniere, Donatello shape **(I/148)**	$75–100
585-4" vase	$100–125
586-8" vase	$125–150
630-4" flower pot	$25–35
630-5" flower pot	$35–45
679-6" vase, also a Tourmaline shape **(I/147)**	$75–100
702-12" vase, Russco shape	$250–300
703-15" vase, Russco shape	$300–400
722-14" vase, Velmoss shape	$300–400
736-8" vase, Orian shape	$100–125

IVORY *(cont.)*

740-10" vase, Orian shape	$125–150
836-12" vase, Crystal Green shape	$250–300
837-14" vase, Crystal Green shape	$300–400
1093-4" candlestick, Topeo shape (pr)	$100–125
1095-4.5" double candelabra Topeo shape (pr)	$150–200
1096-4" double candelabra (pr)	$150–200
1103-4.5" candlestick, Orian shape (pr)	$125–175
1112-5.5" triple candelabra, Moderne shape	$125–150
1212-12" wall pocket, Donatello shape	$150–175
1273-8" wall pocket, Pine Cone shape	$300–400
3645-5" hanging basket, Matt Green shape	$125–150

*IXIA

34 flower frog (I/8)	$125–150
325-5" bowl (I/149)	$125–150
326-4" rose bowl	$150–175
327-6" rose bowl (I/149)	$175–225
328-11.5" centerpiece (I/149)	$300–400
329-7" bowl	$125–175
330-9" bowl	$150–200
331-9" bowl	$175–225
332-12" bowl	$225–275
333-14" bowl	$275–350
346-10" basket	$350–425
357-5" hanging basket	$300–400
640-4" jardiniere	$100–125
640-5" jardiniere (I/150)	$125–150
640-6" jardiniere	$175–225
640-7" jardiniere	$300–400
640-8" jardiniere and pedestal	$1000–1200
640-9" jardiniere	$550–650
640-10" jardiniere and pedestal	$1200–1500
641-5" flower pot and saucer (I/9)	$225–275
852-6" vase (I/150)	$150–175
853-6" vase (I/149)	$150–175
854-7" vase	$150–200
855-7" vase (I/149)	$150–200
856-8" vase	$225–275
857-8" vase	$225–275
858-8" pillow vase (I/149)	$275–350
859-9" vase	$275–350
860-9" vase	$250–300
861-10" vase (I/150)	$300–400
862-10" vase	$300–400
863-10" fan vase	$400–500
864-12" vase (I/149)	$500–600
865-15" vase	$800–900
1125-2" candlestick (pr)	$150–200
1126-4.5" candlestick (pr)	$175–225
1127-4" double candelabra (pr)	$200–250
1128-5" triple candelabra (I/149) (pr)	$275–325

*Comprehensive shape list (see page 12)

*JONQUIL

15-2.5" flower block	$75–85
15-3.5" flower block	$85–95
93-4.5" fan vase	$325–375
94-5.5" flower pot, built-in flower frog	$350–450
95-6.5" ivy jar (I/150)	$500–600
96-7" crocus pot (I/151)	$700–800
97-6" strawberry jar (I/151)	$1200–1500
98-10" low bowl, built-in flower frog (I/151)	$650–750
219-8" x 6" x 3.5" bowl	$350–400
220-10" x 6" x 3.5" bowl	$450–550
223-6" bowl (I/151)	$325–375
323-7" basket (I/151)	$400–500
324-8" basket	$550–650
325-6" basket	$850–1000
326-8" basket (I/151)	$700–800
327-8" basket	$700–800
328-9" basket	$600–700
349-5" hanging basket (I/151)	$550–650
523-3" vase	$200–250
524-4" vase	$225–275
525-5" vase	$275–325
526-6.5" vase	$375–425
527-7" vase	$450–550
528-8" vase	$500–600
529-8" vase	$500–600
530-10" vase (I/150)	$600–700
531-12" vase	$850–1000
538-4" vase	$225–275
539-4" vase	$225–275
540-6" vase (I/151)	$350–400
541-7" vase	$450–500
542-5.5" vase	$350–400
543-6.5" vase	$400–450
544-9" vase	$575–650
580-4" vase	$225–275
581-7" bud vase	$275–325
621-4" jardiniere	$225–275
621-5" jardiniere	$275–325
621-6" jardiniere	$400–450
621-7" jardiniere	$450–550
621-8" jardiniere	$600–700
621-9" jardiniere	$850–1000
621-10" jardiniere and pedestal	$2400–2600
1082-4" candlestick (pr)	$500–600
1268-8.5" wall pocket	$850–1000

*Comprehensive shape list (see page 12)

102-8" combination cigarette box and ashtray (I/153)	$30–40
204-13" compartment tray (I/39)	$40–50
306-12" bowl (I/35)	$40–50
601-6" vase (I/152)	$40–50
602-8" vase (I/39)	$95–125
614-10" vase (I/152)	$95–125
615-6" vase (I/152)	$75–95

*LA ROSE

14-2.5" flower block (same as Corinthian)	$60–75
14-3.5" flower block (same as Corinthian) (I/153)	$75–85
43-4.5" gate (I/153)	$125–175
127-5" bowl	$125–150
127-6" bowl	$150–175
127-7" bowl (I/153)	$150–175
128-5" bowl	$125–150
128-6" bowl	$150–200
128-7" bowl	$150–200
236-4" vase (I/153)	$125–175
237-5" vase	$150–175
238-6" vase (I/153)	$175–225
239-6" vase	$175–200
240-7" vase	$200–250
241-8" vase (I/153)	$225–275
242-9" vase	$275–325
243-10" vase	$350–400
259-5" fern dish	$200–250
259-6" fern dish	$225–275
338-6" hanging basket	$250–300
338-7" hanging basket	$275–325
604-5" jardiniere (I/154)	$150–200
604-6" jardiniere	$200–250
604-7" jardiniere	$275–350
604-8" jardiniere and pedestal	$1000–1200
604-9" jardiniere	$450–550
604-10" jardiniere and pedestal	$1200–1500
605-5" flower pot and saucer	$200–250
605-6" flower pot and saucer	$225–275
605-6" ivy pot, no drain hole (I/154)	$175–225
761-20" umbrella stand	$850–1000
1051-4" candlestick (I/153) (pr)	$150–200
1052-8" candlestick (I/154)	$95–125
1233-7" wall pocket	$325–375
1234-8" wall pocket	$375–450
1235-11" wall pocket	$400–500

*Comprehensive shape list (see page 12)

Cherry Blossom 8.5" factory lamp, non-standard colors (I/154)	$1200–1500
Imperial (Textured) 12" lamp (I/143)	$250–300
Luffa 10" factory lamp, non-standard colors (I/154)	$950–1200
Panel 10" factory lamp, non-standard colors (I/155)	$2000–2500
Sunflower 6" factory lamp, standard colors (I/154)	$3000–3500
Tuscany 8.5" factory lamp, non-standard colors (I/154)	$350–450
Wisteria 641-15" vase, blue, converted into lamp (I/155)	$2000–2500
6.25" factory lamp, based on Ivory/ Tourmaline 679-6" vase, non-standard colors (I/154)	$250–300
9" factory lamp, brown Windsor glaze (I/155)	$575–650
9.5" factory lamp, based on Rozane Royal 814-9.25" vase, non-standard colors (I/154)	$300–400
9.5" factory lamp, based on 103-9" covered jar, non-standard colors (I/154)	$400–500
10.25" factory lamp, Baneda-style motif, non-standard glaze (I/155)	$1200–1500
11.5" factory lamp, red Topeo glaze (I/155)	$750–850

*LATE CAPRI

508-7" basket (I/157)	$125–175
525-5" bowl (Bomm 81/3/5)	$50–60
526-7" bowl	$60–75
527-7" bowl	$60–75
528-9" bowl (Bomm 81/1/1)	$75–85
529-9" bowl (Bomm 81/1/5)	$75–85
530-12" bowl (I/156)	$150–200
531-14" bowl	$100–125
532-15" bowl	$100–125
533-10" bowl (I/157)	$60–75
534-16" bowl	$125–150
552-4" planter (Bomm 81/3/2)	$40–50
553-4" planter (I/156)	$50–60
554-6" planter (Bomm 81/4/3)	$60–75
555-7" planter (I/156)	$40–50
556-6" cornucopia (I/156)	$85–100
557-7" vase	$100–125
563-8" conch shell	$100–125
563-10" conch shell	$125–150
569-10" window box	$85–100
570-12" window box	$100–125
578-7" bud vase (I/156)	$50–60
579-8" bud vase (I/156)	$75–85
580-6" vase (I/156)	$100–125
581-9" vase	$150–175
583-9" vase	$125–150
586-12" vase	$125–150
593-12" vase	$150–200
597-7" ashtray (I/157)	$40–50
598-9" ashtray	$75–85
599-13" ashtray	$85–100
1797-5" x 2" bowl, wok	$60–75
1798 cigarette holder, kettle	$75–85
1799-6.5" ashtray, skillet	$85–100
C1009-8" bowl, footed	$85–100
C1010-10" planter	$75–85

*Comprehensive shape list (see page 12)

*LAUREL

	Green	Red or Yellow
250-6.25" rose bowl	$375–450	$325–375
251-6.5" bowl (I/158/1/2)	$275–325	$225–275
252-8" bowl (Monsen II/83/2)	$325–375	$275–325
253-14" bowl (Monsen II/84/2)	$650–750	$500–600
667-6" vase	$325–375	$275–325
668-6" vase (I/157)	$325–375	$275–325
669-6.5" vase	$350–400	$300–350
670-7.25" vase	$400–500	$350–400
671-7.25" vase (I/157)	$400–500	$350–400
672-8" vase	$550–650	$400–500
673-8" vase (I/283)	$500–600	$375–450
674-9.25" vase (I/158)	$600–700	$400–500
675-9" vase	$750–850	$500–600
676-10" vase	$850–1000	$750–850
677-12.25" vase (I/158)	$1000–1200	$850–1000
678-14.25" vase	$1200–1500	$1000–1200
1094-4.5" candlestick (I/158) (pr)	$375–450	$325–375
8.5" bowl (I/158/2)	$400–500	$350–400

*Comprehensive shape list (see page 12)

*LOMBARDY

15-2.5" flower block	$65–75
15-3.5" flower block	$75–85
175-5" bowl	$100–125
175-6" bowl	$125–150
175-7" bowl (I/159)	$125–150
342-5" hanging basket	$225–275
342-6" hanging basket	$275–325
350-6" vase (I/281)	$125–150
350-8" vase (I/159)	$275–325
350-10" vase (I/159)	$325–375
613-6" jardiniere (I/159)	$150–200
613-7" jardiniere	$225–275
613-8" jardiniere	$325–375
613-9" jardiniere (I/158)	$400–500
613-10" jardiniere	$500–600
613-12" jardiniere	$600–700
1256-8" wall pocket (I/159)	$400–500
1257-8" wall pocket	$450–550

*Comprehensive shape list (see page 12)

*LOTUS

L3-10" vase (I/160)	$200–250
L4-10" x 8" pillow vase (I/160)	$225–275
L5-3" candlestick (pr)	$125–175
L6-9" bowl	$125–150
L7-10" window box (I/159)	$125–150
L8-7" wall pocket	$300–400
L9-4" planter (I/159)	$75–95

*Comprehensive shape list (see page 12)

*LUFFA

17-4.5" flower block	$75–85
255-6" rose bowl (I/161)	$250–300
257-8" bowl (I/161)	$175–200
258-12" bowl (I/160)	$200–250
631-4" jardiniere	$125–175
631-5" jardiniere	$175–225
631-6" jardiniere	$250–300
631-7" jardiniere	$300–400
631-8" jardiniere and pedestal	$1000–1200
631-9" jardiniere	$500–600
631-10" jardiniere and pedestal	$1200–1500
683-6" vase	$225–275
684-6" vase (I/161)	$225–275
685-7" vase (I/161)	$250–300
686-7" vase (I/161)	$250–300
687-8" vase (I/161)	$300–350
688-8" vase (I/161)	$325–375
689-8" vase (I/161)	$350–400
690-9" vase	$400–500
691-12" vase	$650–750
692-14" vase	$850–1000
693-15" vase	$1000–1200
771-15" x 10" sand jar	$850–1000
1097-4.5" candlestick (pr)	$450–550
1272-8" wall pocket	$750–850

*Comprehensive shape list (see page 12)

5-8" compote, green (I/163)	$125–150
8-6" compote, pink (I/162)	$125–175
15-2.5" flower block, orange (I/163)	$20–25
15-3.5" flower block, pink or gray (I/163)	$25–30
82-4" rose bowl, orange (I/163)	$75–95
86-12" bowl, pink (I/162)	$150–200
170-7" vase, blue	$125–150
174-12" vase, blue (Bomm 214/bottom right)	$225–275
227-13" vase, gray (I/162)	$200–250
295-6" basket, yellow (I/163)	$125–175
298-8" basket, pink (I/163)	$200–250
310-9" basket, pink (I/163)	$250–300
1020-10" candlestick (I/162, 163)	yellow, $75–95
	orange, $95–125

*MAGNOLIA

2-8" cookie jar (I/8)	$450–500
3-3" mug (I/7)	$100–125
4 teapot	$350–400
4-C creamer	$85–100
4-S sugar bowl	$85–100
5-10" compote	$150–200
13 bookend (pr)	$250–300
13-6" ewer (I/164)	$150–200
14-10" ewer (I/164)	$250–325
15-15" ewer (I/164)	$700–800
28 ashtray	$125–150
49 flower frog	$100–125
86-4" vase	$100–125
87-6" vase	$150–175
88-6" vase	$150–175
89-7" vase	$150–200
90-7" vase	$150–200
91-8" vase	$175–225
92-8" vase	$175–225
93-9" vase (I/164)	$225–275
94-9" vase	$275–325
95-10" vase	$300–350
96-12" vase (I/164)	$400–500
97-14" vase (I/164)	$500–600
98-15" vase (I/164)	$700–800
99-16" vase	$850–1000
100-18" floor vase	$1000–1200
179-7" bud vase (I/164)	$150–175
180-6" vase	$150–200
181-8" vase	$175–225
182-5" flower arranger	$125–175
183-6" fan vase	$150–200
184-6" cornucopia	$125–175
185-8" cornucopia	$175–225
186-4.5" gate	$150–200
383-7" basket	$175–225
384-8" basket	$200–250
385-10" basket	$275–350
386-12" basket	$350–450
388-6" window box	$150–200
389-8" window box	$175–225
446-4" rose bowl (I/164)	$125–175
446-6" rose bowl	$150–200
447-6" bowl	$125–150
448-8" bowl	$150–200
449-10" bowl	$175–225
450-10" bowl	$175–225
451-12" bowl	$225–275
452-14" bowl	$250–325
453-6" conch shell	$175–225
454-8" conch shell	$225–275
469-5" hanging basket	$225–275
665-3" jardiniere	$85–100

665-4" jardiniere (I/164)	$100–125
665-5" jardiniere	$150–200
665-8" jardiniere and pedestal	$1000–1200
665-10" jardiniere and pedestal	$1200–1500
666-5" flower pot and saucer	$200–250
1156-2.5" candlestick (pr)	$125–150
1157-4.5" candlestick (pr)	$175–225
1294-8" wall pocket	$300–400
1327 ice-lip pitcher (I/7)	$450–550

*Comprehensive shape list (see page 12)

MAJOLICA

201-12.5" bud vase, blended pink and
 brown (I/168) $150–200
313-8" fern dish, blended colors (I/165) $95–125
412-8" x 20" jardiniere, fleurs de lis, hand
 decorated in 4 colors (I/169) $175–225
414-14" x 33" jardiniere and pedestal,
 lion-head handles and scroll work,
 hand decorated in 6 colors (I/169) $1200–1500
451-7" jardiniere, iris, hand decorated (I/169) $200–250
459-10" x 25" jardiniere and pedestal, apple
 tree branches, blended green and
 pink (I/165) $500–600
468-16" jardiniere, storks, solid color (I/169) $125–175
475-8" x 21.5" jardiniere and pedestal,
 castle in landscape, hand decorated
 in 4 colors (I/168) $750–950
506-12" jardiniere, blended green, rose
 and dark brown (I/167) $250–300
612-7.5" x 5.5" cuspidor, blended green
 and brown (I/165) $125–150
710-22" x 10.5" umbrella stand, ornate
 scrolls and frieze work, blended green,
 yellow and pink (I/168) $300–350
711-26" x 11" x 8.5" umbrella stand, Art
 Nouveau maidens, hand decorated
 in 8 colors (I/168) $1800–2200
4.5" Uncle Sam bank, solid color (I/169) $175–225
6.5" pitcher, Utility Ware, solid color with
 cream lining (I/31) $75–95
7.5" pitcher, Utility Ware (Landscape)
 design, blended green and brown (I/30) $150–200
7.5" pitcher, Utility Ware (Landscape)
 design, Hand Decorated (I/30) $175–225
10" x 28" jardiniere and pedestal,
 Mostique design, blended green
 and brown (I/9) $1500–1800

K14-8.5" vase, Mara wafer (I/170/1) $2500–3000
K22-8" vase, hand-painted with stylized
 scroll-like motifs, unmarked (I/170/2) $1500–2000

MATT GREEN

1-3" bouquet holder (covered), matte bright green (I/174)	$75–95
1-12" vase, matte light and medium green, some organic texture (I/174)	$1200–1500
4-2" match holder, matte dark green (I/174)	$50–60
319-7" fern dish, matte medium green with veining (I/16)	$350–450
468-10" x 29" jardiniere and pedestal, matte medium green (I/175/1/1)	$1800–2200
508-10" x 34" jardiniere and pedestal, matte medium green (I/175)	$1500–1800
549-4" flower pot, matte bright green (I/174)	$75–95
727-20" umbrella stand, matte medium green (I/175)	$950–1200
974-11.5" vase, matte medium green (I/32/1/1)	$175–225
1201-14.5" wall pocket, semigloss dark green (I/1)	$375–450
1204-10" wall pocket, semigloss dark green (I/174)	$250–300
1205-7" wall pocket, matte medium green (I/32)	$225–275
1206-5" wall pocket, matte bright green (I/10)	$175–200
3656-5" hanging basket, semigloss pea green (I/174)	$175–200
3656-5" hanging basket, matte light green with veining (I/174)	$175–200
3676-6" hanging basket, matte medium green (I/174)	$200–250
3" ashtray, attributed to Roseville (I/174/1/3)	$75–95
7.25" wall pocket, attributed to Roseville (I/10/1/2)	$175–225

Item	Price
71-4" vase	$40–50
72-5" vase (I/176)	$50–60
73-6" vase	$60–75
90-4" planter	$50–60
1003-8" vase	$100–125
1004-9" vase	$100–125
1006-12" vase	$125–150
1009-8" bowl, footed	$85–100
1010-10" bowl	$85–100
1011-12" bowl	$100–125
1012-10" basket	$125–150
1014-8" corner wall pocket	$175–225
1016-10" vase	$125–150
1017-12" vase	$150–175
1018-6" cornucopia (I/176)	$60–75
1101-5" pitcher (I/175)	$75–95
1102-5" pitcher	$60–75
1103-6" pitcher (I/176)	$60–75
1104-7" lemonade pitcher (I/176)	$125–150
1105-8" pitcher	$95–125
1106-10" pitcher (I/176)	$125–175
1107-12" tankard (I/176)	$125–175
1109-4" planter	$50–60
1110-4" planter (I/176)	$50–60
1111-5" planter	$60–75
1112-8" window box	$75–95
1113-8" window box	$75–95
1114-8" window box (I/175)	$75–95
1115-10" bowl	$85–100
1116-10" window box	$95–125
1117-5" flower pot and separate saucer (I/176)	$95–125
1118 bowl, shell shape	$75–100
1119 bowl, shell shape	$100–125
1120 bowl, shell shape	$100–125
1121-5" coffee pot (I/176)	$125–150
1122 teapot	$125–150
1151 candlestick, shell shape (pr)	$75–100

*Comprehensive shape list (see page 12)

*MING TREE

508-8" basket (I/177)	$150–200
509-12" basket (I/177)	$225–275
510-14" basket (I/177)	$300–350
516-10" ewer	$200–250
526-9" planter	$150–175
527-9" bowl (I/177)	$175–225
528-10" bowl	$150–175
551 candlestick (pr)	$100–125
559 bookend (I/177) (pr)	$150–200
561-5" hanging basket	$225–275
563-8" conch shell (I/177)	$100–125
566-8" wall pocket	$275–325
568-8" planter	$125–175
569-10" window box	$150–200
572-6" vase	$125–150
581-6" vase	$100–125
582-8" vase	$150–175
583-10" vase (I/177)	$225–275
584-12" vase (I/177)	$275–325
585-14" vase	$400–500
586-15" vase (I/177)	$650–750
599 ashtray (I/177)	$75–100

*Comprehensive shape list (see page 12)

*MOCK ORANGE

900-4" jardiniere	$85–100
901-6" jardiniere	$125–150
903-10" jardiniere (I/178)	$500–600
903-10" jardiniere and pedestal	$1200–1500
908-6" basket	$150–175
909-8" basket	$175–225
910-10" basket (I/179)	$200–250
911-10" basket	$225–275
916-6" ewer	$125–150
918-16" ewer	$450–550
921-6" cornucopia (I/179)	$95–125
926-6" bowl	$85–100
927-6" bowl (I/178)	$95–125
929-10" bowl	$125–150
930-8" rose bowl	$200–225
931-8" bowl	$125–150
932-8" cornucopia	$125–150
932-10" bowl	$125–150
933-11" bowl	$150–175
934-10" bowl	$125–150
941-5" rose bowl	$150–175
951-2" candlestick (pr)	$100–125
952-5" planter	$85–100
953-6" planter	$85–100
954-7" planter	$95–125
956-8" planter	$95–125
957-8" planter (I/178)	$95–125
961-5" hanging basket	$275–325
968-8" window box	$125–150
969-12" window box	$150–175
971-C covered creamer	$75–85
971-P teapot (I/178)	$150–200
971-S covered sugar bowl	$75–85
972-7" fan vase	$125–175
973-8" vase, ewer shape	$175–225
974-8" vase (I/179)	$150–200
979-7" bud vase	$95–125
980-6" vase	$125–150
981-7" pillow vase	$150–175
982-8" vase (I/27/3/3)	$150–175
983-7" vase	$125–175
984-10" vase (I/178)	$150–200
985-12" vase	$225–275
986-18" floor vase	$600–700

*Comprehensive shape list (see page 12)

MODERN ART

447-9" jardiniere, poppies, dark green
and aqua (I/179) $400–500

448-10" jardiniere, blackberries, blended
dark green and aqua (I/180) $500–600

457-5" jardiniere, nasturtiums, dark green
border on ivory (I/180) $175–225

457-8" jardiniere, carnations, dark green
border on ivory (I/180) $300–400

457-9" jardiniere, thistles, medium and
dark green, ornate gilt curves (I/179) $400–500

457-10" x 31" jardiniere, tulips, dark red
with gilt border (I/179) $500–600

*MODERNE

26-7" flower frog	$150–200
27 flower frog	$175–225
295-6" footed bowl	$200–250
296-6" bowl	$150–175
297-6" footed bowl	$200–250
298-6" footed bowl	$200–250
299-6" rose bowl	$200–250
300-9" bowl	$125–175
301-10" bowl	$175–225
302-14" bowl	$350–450
787-6" vase (I/181)	$125–150
788-6" vase	$125–150
789-6" vase	$125–150
790-7" bud vase	$150–175
791-8" bud vase (I/181)	$200–250
792-7" triple bud vase (I/181)	$250–300
793-7" vase	$175–225
794-7" vase	$175–225
795-8" vase	$200–250
796-8" vase	$200–250
797-8" vase (I/181)	$200–250
798-9" vase (I/181/1/1)	$225–275
799-9" vase (I/181)	$400–500
800-10" vase (I/181)	$275–350
801-10" vase (I/181)	$275–350
802-12" vase	$400–500
803-14" vase	$500–600
1110-2" candlestick (pr)	$125–150
1111-4.5" candlestick (pr)	$175–225
1112-5.5" triple candelabra	$225–275

*Comprehensive shape list (see page 12)

MONGOL

234-8" basket, oxblood red, unmarked (I/182) $950–1200

970-10" vase, Rozane Royal Shape, sterling silver overlay, Mongol wafer (I/1) $2500–3000

989-5" pillow vase, oxblood red, Rozane Ware wafer (I/182) $750–950

M900-6" tyge, or "3-handled drinking cup," bright red with oxblood tones, Mongol wafer (I/182) $750–950

R16-7.5" ewer, mottled oxblood and medium red, Mongol wafer (I/182) $600–750

14" vase, bright red, Mongol wafer (I/182) $1800–2200

*MONTACELLO

225-9" bowl (I/183)	$450–550
332-6" basket	$750–850
333-6" basket (I/183)	$700–800
555-4" vase (I/282/1/2)	$300–400
556-5" vase (I/184)	$375–450
557-5" vase	$400–500
558-5" vase (I/183)	$375–450
559-5" vase (I/183)	$450–550
560-6" vase (I/183)	$450–550
561-7" vase (I/183)	$500–600
562-7" vase (I/184)	$600–700
563-8" vase	$700–800
564-9" vase	$850–1000
565-10" vase	$1200–1400
579-4.75" vase (I/282/1/3)	$300–400
1085-4.5" candlestick (I/183) (pr)	$550–650

*Comprehensive shape list (see page 12)

*MORNING GLORY

	Green	White
120-7" pillow vase (I/184)	$550–650	$475–550
268-4" rose bowl	$450–500	$400–450
269-6" rose bowl	$600–700	$550–650
270-8" x 6" x 4.5" bowl	$500–600	$450–550
271-10" x 5" x 5" bowl	$600–700	$550–650
340-10" basket	$1200–1400	$1000–1200
723-5" vase, flower pot shape (I/184)	$450–525	$375–450
724-6" vase (I/185)	$450–550	$400–500
725-7" fan vase (I/185)	$550–650	$450–550
726-8" vase (I/185)	$750–850	$600–700
727-8" vase	$750–850	$600–700
728-9" vase	$800–900	$650–750
729-9" vase (I/184)	$850–1000	$750–850
730-10" vase	$1000–1200	$850–1000
731-12" vase	$1500–1800	$1200–1500
732-14" vase (I/185)	$2000–2500	$1800–2000
1102-4.5" candlestick (pr)	$1000–1200	$850–1000
1275-8" wall pocket	$1400–1600	$1200–1400

*Comprehensive shape list (see page 12)

*MOSS

24 flower frog	$175–200
25 flower frog	$175–200
289-4" rose bowl	$175–225
290-6" rose bowl	$250–300
291-5" bowl	$175–200
291-6" bowl	$200–225
291-7" bowl	$225–275
292-8" bowl	$275–325
293-10" bowl	$325–375
294-12" bowl	$375–450
353-5" hanging basket	$375–450
635-4" jardiniere	$175–225
635-5" jardiniere	$225–275
635-6" jardiniere (I/186)	$275–350
635-7" jardiniere (I/186)	$350–450
635-8" jardiniere and pedestal	$1500–1800
635-9" jardiniere	$700–800
635-10" jardiniere and pedestal	$2000–2500
637-5" flower pot and saucer	$300–350
773-5" vase	$200–250
774-6" vase (I/185)	$225–275
775-6" vase	$225–275
776-7" vase	$250–300
777-7" vase (I/186)	$250–300
778-7" fan vase	$300–350
779-8" vase (I/186)	$375–450
780-8" vase (I/185)	$350–400
781-8" pillow vase	$400–500
782-9" vase (I/185)	$500–600
783-9" vase	$500–600
784-10" vase	$600–700
785-12" vase	$700–800
786-14" vase (I/186)	$850–1000
1107-4.5" candlestick (I/186) (pr)	$200–250
1108 triple candelabra	$350–400
1109-2" candlestick (pr)	$150–200
1278-8" wall pocket	$750–850
1279-4" wall pocket, flower pot shape	$1000–1200

*Comprehensive shape list (see page 12)

*MOSTIQUE

1-6" vase (I/187)	$175–225
2-6" vase (I/187)	$175–225
3-6" vase	$175–225
4-6" vase (I/187)	$175–225
5-6" vase	$175–225
6-6" vase	$175–225
7-8" vase	$250–300
8-8" vase	$250–300
9-8" vase	$250–300
10-8" vase	$250–300
11-8" vase	$250–300
12-8" vase	$250–300
13-8" vase (I/187)	$250–300
14-8" vase	$250–300
[15]-2.5" flower block	$20–25
[15]-3.5" flower block	$30–35
15-10" vase	$300–375
16-10" vase	$300–375
17-10" vase (I/188)	$300–375
18-10" vase	$300–375
19-10" vase (I/188)	$300–375
20-10" vase	$300–375
21-10" vase	$300–375
22-10" vase	$300–375
23-10" vase	$300–375
24-10" vase (I/188)	$300–375
25-12" vase	$375–450
26-12" vase	$375–450
27-12" vase	$375–450
28-12" vase	$375–450
29-12" vase	$375–450
30-12" vase	$375–450
72-5" bowl	$100–125
72-6" bowl	$125–150
72-8" bowl	$150–175
73-5" bowl	$100–125
73-6" bowl	$125–150
73-7" bowl	$125–150
99-10" crocus pot and saucer	$850–1000
100-10" strawberry jar and saucer	$1000–1200
131-4" bowl	$100–125
131-5" bowl	$125–150
131-6" bowl	$125–150
131-7" bowl	$150–175
164-6" vase (I/187)	$175–225
164-8" vase	$225–275
164-10" vase	$275–350
164-12" vase	$350–450
164-15" vase	$700–800
221-6" bowl	$275–350
222-8" bowl	$350–400
253-5" fern dish	$175–225
253-6" fern dish	$225–275
334-6" hanging basket	$300–375
334-8" hanging basket	$350–450
532-6" vase	$275–350

532-8" vase	$350–450
532-10" vase (I/188)	$450–550
532-12" vase	$600–700
533-8" vase	$400–500
534-8" vase	$500–600
535-8" vase	$400–500
536-9" vase (I/188)	$500–600
537-10" vase	$550–650
‡571-7" jardiniere	$200–250
‡571-8" jardiniere	$275–350
‡571-9" jardiniere	$375–450
‡571-10" jardiniere	$475–550
‡571-10" x 28" (or 29") jardiniere and pedestal	$1000–1200
‡571-12" x 33" jardiniere and pedestal	$1200–1500
‡573-7" jardiniere	$200–250
‡573-8" jardiniere	$275–350
‡573-9" jardiniere	$375–450
‡573-10" jardiniere	$475–550
‡573-12" jardiniere	$550–650
592-6" jardiniere	$200–250
592-8" jardiniere	$350–400
592-10" jardiniere	$475–550
593-7" jardiniere	$200–250
593-9" jardiniere	$375–450
593-12" jardiniere	$550–650
606-6" jardiniere	$200–250
606-7" jardiniere (I/187)	$250–300
606-8" jardiniere	$350–400
606-9" jardiniere	$450–550
606-10" jardiniere and pedestal	$1200–1400
622-7" jardiniere	$375–450
622-8" jardiniere	$500–600
622-9" jardiniere	$600–700
622-10" jardiniere and pedestal	$1500–1800
631 cuspidor	$400–500
1083-4" candlestick (I/188)	$400–500
1224-10" wall pocket	$550–650
1224-12" wall pocket	$650–750
7" bowl (I/187/1/3)	$150–175
7" compote (I/11/4)	$250–300
20" umbrella stand (I/188/2/1)	$950–1200

‡Note: Mostique jardiniere 571 is probably shown in Huxford I/57/1/3. (A jardiniere and pedestal are known in that design.) If this assumption is correct, Mostique shape 573 is shown in Huxford II/75/3/3.

*Comprehensive shape list (see page 12)

*NORMANDY

341-5" hanging basket (I/189)	$325–375
341-6" hanging basket (I/189)	$350–400
609-7" jardiniere	$350–400
609-8" jardiniere (I/189)	$475–550
609-9" jardiniere (I/189)	$500–600
609-10" jardiniere	$600–700
609-10" jardiniere and pedestal	$1500–1800
768-14" x 12" sand jar	$800–900
20" umbrella stand (I/189)	$950–1200

*Comprehensive shape list (see page 12)

OLD IVORY (TINTED)

3 combination smoker set, green tint (I/191) $275–325
201-4" planter, tan tint, red stippling (I/192) $125–150
210-4" x 8" combination planter with liner,
 green tint (I/21) $175–225
489-7" jardiniere, Bacchantes, tan tint,
 gilt tracing, hand-painted green
 trim (I/190) $500–600
533-9" jardiniere, tan tint (I/190) $150–175
534-10" x 30" jardiniere and pedestal,
 pale tan tint, hand-painted red and
 green trim (I/190) $950–1200
621 cuspidor, fern trail design, tan tint (I/192) $125–175
1205-7" wall pocket, tan tint (I/32) $150–200
4" hair receiver, blue tint (I/192) $150–200
4" powder box, green tint (I/191) $150–200
3" ring holder, blue tint (I/192) $95–125
4.25" stein, tan tint (I/191) $95–125
13.5" tankard, tan tint (I/191) $300–350

OLYMPIC

5" stein, seated youth, three-line
 Olympic mark (I/193) $1200–1500
13" vase, three figures, black
 ink ROZANE POTTERY
 (I/193) NPD (in a museum collection)
14.25" urn, "Lampetia Complaining to
 Apollo," three-line
 Olympic mark (I/193) NPD (in a museum collection)

*ORIAN

272-10" bowl (I/194)	$250–300
273-12" x 5" x 4.5" bowl	$300–400
274-6" rose bowl	$250–300
275-12" x 8" bowl	$275–325
733-6" vase (I/194)	$175–225
734-7" vase (I/194)	$225–275
735-7" vase	$225–275
736-8" vase	$250–300
737-7" vase (I/194)	$275–325
738-9" vase	$300–350
739-9" vase	$300–350
740-10" vase (I/194)	$350–400
741-10" vase (I/194)	$400–450
742-12" vase (I/194)	$450–550
743-14" vase (I/194)	$700–800
1103-4.5" candlestick (pr)	$300–400
1276-8" wall pocket	$1000–1200

*Comprehensive shape list (see page 12)

*PANEL

285-6" vase (I/195/1/3)	$150–175
291-8" vase	$225–275
292-8" vase (I/195/3/4)	$225–275
293-8" vase	$275–325
294-8" vase	$225–275
295-9" covered vase	$350–400
296-10" vase, nude (I/195/1/2)	$1200–1400
297-10" vase (I/195/3/1)	$300–350
298-11" vase, nude (I/24)	$1200–1500
299-12" vase (I/195/3/2)	$375–450
1057-8" candlestick (pr)	$350–450
1244-9" wall pocket (Huxford II/165/4/3)	$275–325
4" bowl (Huxford II/76/1/3)	$125–150
4" rose bowl (I/195/3/3)	$125–175
5" bowl (author's collection)	$100–125
6" fan vase, nude (I/195/2/2)	$600–750
7" vase (I/195/1/1)	$200–250
8" fan vase, nude (I/195/2/1)	$750–950
2.5" candlestick (Huxford I/77/1/4) (pr)	$150–200
6" pillow vase (Huxford I/77/1/5)	$225–275
6" vase (Huxford II/76/1/1)	$150–175
6" x 12" window box (Huxford II/76/2/2)	$375–450
6.5" gate (Huxford I/77/1/1)	$175–225
7" wall pocket, nude (Huxford II/165/4/2)	$600–700
9" wall pocket (Huxford II/165/4/4)	$275–325

*Comprehensive shape list (see page 12)

PASADENA PLANTERS

L14-4" planter (I/196) $30–35
L14-4" planter, original metal frame (I/196) $40–50
L17-9" planter (I/196) $60–75
L19-8" planter, original metal frame (I/196) $50–60
L21-12" planter (I/196) $60–75
L31-4" planter (I/35) $30–35
L33-6.5" planter (I/196) $50–60
L35-10" planter (I/196) $60–75

PAULEO

6-7.25" pitcher, matte mottled brown (I/30)　$550–650

814-9.25" vase, Rozane Royal
　　shape, veined lustre (I/198/2/3)
　　　　　　　　　NPD (in a museum collection)

E64-14.75" vase, Crystalis shape,
　　mottled matte (I/198)　$1800–2200

R10-20" vase, decorated with chrysanthemums,
　　Moose lodge decal on obverse (I/197/2)　$2500–3000

11.5" vase, veined lustre (I/198/2/4)
　　　　　　　　　NPD (in a museum collection)

13.5" vase, deep red lustre (I/198/1/1)　$1200–1500

15" vase, decorated with landscape (I/197/3)　$2200–2500

17" vase, decorated with grapes (I/197/1)　$1800–2200

18" vase, matte mottled dark blue
　　and black (I/198)　$2500–3000

*PEONY

NOTE: Add 25–50% for rust.

2-3.5" mug	$75–85
3 teapot	$275–350
3-C creamer	$75–85
3-S sugar bowl	$75–85
3-10" compote	$150–175
4-10" compote	$175–200
7-6" ewer	$125–175
8-10" ewer	$250–300
9-15" ewer (I/8)	$500–600
11 bookend (pr)	$225–275
27 ashtray	$100–125
47 flower arranger (I/200)	$125–150
57-4" vase	$100–125
58-6" vase (I/199)	$125–150
59-6" vase	$125–150
60-7" vase	$125–150
61-7" vase (I/200)	$125–150
62-8" vase	$150–175
63-8" vase	$150–175
64-9" vase (I/199)	$175–225
65-9" vase	$175–225
66-10" vase (I/199)	$225–275
67-12" vase (I/199)	$275–350
68-14" vase	$450–550
69-15" vase	$600–700
70-18" floor vase	$750–950
167-4.5" gate	$125–175
168-6" vase	$100–125
169-8" vase (I/200)	$150–200
170-6" cornucopia	$100–125
171-8" cornucopia (I/200)	$125–150
172 double cornucopia	$150–200
173-7" bud vase (I/200)	$100–125
376-7" basket	$150–200
377-8" basket (I/200)	$200–250
378-10" basket (I/199)	$250–300
379-12" basket (I/199)	$300–400
386-6" window box	$125–150
387-8" window box	$150–175
427-4" rose bowl	$125–150
427-6" rose bowl	$150–175
428-6" bowl	$100–125
429-8" bowl	$125–150
430-10" bowl	$150–175
431-10" bowl	$150–175
432-12" bowl	$200–250
433-14" bowl	$250–300
434-6" tray	$125–150
435-10" tray	$150–175
436 conch shell	$175–200
467-5" hanging basket	$225–275
661-3" jardiniere	$100–125
661-4" jardiniere	$125–150
661-5" jardiniere	$150–175
661-6" jardiniere	$175–225

*PEONY *(cont.)*

661-8" jardiniere and pedestal	$850–1000
661-10" jardiniere and pedestal	$1000–1200
662-5" flower pot and saucer	$175–225
1151-2" candlestick (pr)	$100–125
1152-4.5" candlestick (pr)	$125–175
1153 double candelabra (I/199)	$100–125
1293-8" wall pocket	$275–350
1326-7.5" ice-lip pitcher	$225–275

*Comprehensive shape list (see page 12)

*PINE CONE

	Blue	Brown	Green
1-4.75" bookend (pr)	$500–600	$400–500	$350–400
1-8" x 5" wall shelf	$600–700	$500–600	$450–500
20-4" flower frog	$275–350	$225–275	$175–225
21-5" flower frog	$300–375	$225–275	$200–225
25 ashtray (l/201)	$250–300	$200–250	$175–200
32 flower frog	$250–300	$200–250	$150–175
33 flower frog	$250–300	$200–250	$150–175
112-7" bud vase (l/21)	$175–200	$150–175	$150–175
113-8" triple bud vase	$375–450	$300–350	$250–300
114-8" pillow vase	$475–550	$400–475	$325–375
121-7" pillow vase	$325–375	$250–300	$200–225
124-5" vase, flower pot shape	$375–450	$275–350	$225–275
126-6" cornucopia	$225–275	$200–225	$175–200
128-8" cornucopia	$275–350	$225–275	$200–225
261-6" fern dish	$350–425	$275–350	$225–275
261-6" rose bowl	$400–500	$325–375	$275–325
262-10" bowl	$475–550	$375–425	$300–350
263-14" bowl	$650–750	$500–600	$400–500
276-11" bowl	$550–650	$400–500	$350–400
278-4" rose bowl	$375–450	$275–350	$225–275
279-9" x 6" bowl	$400–500	$300–350	$250–300
288-7" tray, or wall plate	$650–750	$500–600	$400–475
320-5" bowl	$275–350	$225–275	$175–225
321-9" bowl	$400–500	$300–350	$250–300
322-12" bowl	$550–650	$400–475	$350–400
323-15" bowl	$650–750	$450–575	$400–450
324-6" centerpiece	$750–850	$550–650	$450–550
338-10" basket (l/201)	$600–700	$450–550	$400–450
339 basket	$650–750	$500–600	$450–500
352-5" hanging basket	$600–700	$450–550	$375–450
352-8" basket, built-in flower frog	$600–700	$450–550	$350–400
353-12" basket	$800–900	$600–700	$450–550
354-6" bowl	$250–300	$175–225	$150–175
355-8" bowl	$325–375	$250–300	$200–250
356-12.5" x 5" x 3.5" centerpiece	$800–900	$650–750	$500–600
379-9" x 3" x 3.25" window box	$500–600	$375–450	$300–350
380-10" x 5.5" window box	$1500–2000	$1200–1500	$1000–1200
632-3" jardiniere	$175–225	$150–175	$125–150
632-4" jardiniere	$250–300	$175–225	$150–175
632-5" jardiniere	$350–400	$250–300	$175–225
632-6" jardiniere (l/33/1/1)	$400–500	$350–400	$275–350
632-7" jardiniere	$550–650	$400–500	$350–400
632-8" jardiniere and pedestal	$2000–2500	$1800–2200	$1500–1800

*PINE CONE *(cont.)*

	Blue	Brown	Green
632-9" jardiniere	$1000–1200	$800–900	$650–750
632-10" jardiniere and pedestal	$3000–4000	$2200–2500	$1800–2200
632-12" jardiniere and pedestal	$4000–5000	$2500–3000	$2200–2500
633-5" flower pot and saucer	$400–500	$300–375	$250–300
704-7" vase	$450–550	$350–400	$300–350
705-9" bud vase	$400–500	$300–375	$250–300
706-8" vase	$500–600	$400–500	$350–400
707-9" vase	$600–700	$475–550	$400–450
708-9" ewer	$850–1000	$700–800	$600–675
709-10" vase (I/201)	$800–900	$650–750	$450–550
711-10" vase (I/36 and 202)	$950–1200	$800–900	$650–750
712-12" vase (I/202)	$850–1000	$700–800	$600–700
713-14" vase	$1500–1800	$1200–1500	$950–1200
745-7" vase	$300–375	$250–300	$200–250
746-8" vase	$400–500	$325–375	$250–300
747-10" vase (I/202)	$650–750	$500–600	$400–500
748-6" vase (I/201)	$300–375	$225–275	$175–225
776-14" sand jar	$2500–3000	$2200–2500	$1800–2200
777-20" umbrella stand	$3000–3500	$2500–3000	$2200–2500
804-10" vase	$650–750	$500–600	$400–500
805-12" vase	$800–900	$700–800	$600–700
806-12" vase	$850–1000	$750–850	$650–750
807-15" vase	$2500–3000	$1800–2200	$1400–1600
838-6" vase (I/201)	$275–350	$200–250	$175–200
839-6" vase	$275–350	$200–250	$175–200
840-7" vase	$350–400	$300–350	$250–300
841-7" vase	$400–450	$325–375	$275–325
842-8" vase	$450–550	$400–450	$350–400
843-8" vase	$450–550	$400–450	$350–400
844-8" vase	$400–450	$325–375	$275–325
845-8" fan vase	$500–600	$450–500	$400–450
846-9" vase (I/201)	$550–650	$475–525	$425–475
847-9" vase	$550–650	$475–525	$425–475
848-10" vase (I/201)	$700–800	$625–675	$575–625
849-10" vase	$650–700	$575–625	$525–575
850-14" vase	$1500–1800	$1200–1500	$1000–1200
851-15" ewer	$1800–2200	$1500–1800	$1200–1500
906-6" vase	$275–325	$225–275	$175–225
907-7" vase	$375–450	$325–375	$275–325
908-8" vase	$450–550	$375–450	$325–375
909-10" ewer	$650–700	$575–625	$525–575
910-10" vase	$700–800	$625–675	$575–625
911-12" vase	$800–900	$700–800	$600–700
912-15" vase	$2500–3000	$1800–2200	$1200–1500
913-18" floor vase	$2750–3250	$2200–2500	$1500–1800
960-4" vase, mug shape	$175–200	$150–175	$125–150
1099C-4.5" candlestick (pr.)	$400–450	$275–325	$225–275

	Blue	Brown	Green
1106-5.5" triple candelabra	$400–500	$300–375	$250–300
1123 candlestick (pr)	$350–400	$275–350	$225–275
1124-4.5" double candelabra	$300–350	$250–300	$200–250
1273-8" wall pocket	$650–750	$500–600	$450–500
1283-4" wall pocket, flower pot shape	$1000–1200	$750–950	$600–700
1321 ice-lip pitcher (I/201)	$950–1200	$800–900	$700–800

*Comprehensive shape list (see page 12)

*PINE CONE MODERN

	Blue	Brown	Green
400-4" jardiniere	$250–300	$200–250	$175–200
401-6" jardiniere			
(I/33/1/2)	$400–500	$350–400	$275–350
402-8" jardiniere	$850–950	$700–800	$650–750
403-10" jardiniere	$1000–1200	$800–900	$750–850
405-8" jardiniere			
and pedestal	$2000–2500	$1800–2200	$1500–1800
406-10" jardiniere			
and pedestal	$2500–3000	$2200–2500	$1800–2200
408-6" basket	$400–500	$350–400	$300–350
409-8" basket	$500–600	$400–500	$375–450
410-10" basket	$600–700	$500–600	$450–550
411-10" basket	$700–800	$600–700	$550–650
414-5" tumbler	$300–350	$250–300	$225–275
415-9" pitcher			
(I/204)	$800–900	$700–800	$600–700
416-18" ewer	$1800–2200	$1500–1800	$1500–1800
421-6" cornucopia,			
based on			
Pine Cone 126-6"			
cornucopia	$250–300	$200–250	$175–225
422-8" cornucopia,			
based on			
Pine Cone 128-8"			
cornucopia	$275–325	$225–275	$200–250
425-6" bowl	$225–275	$175–225	$150–200
426-6" bowl	$250–300	$200–250	$175–225
427-8" bowl	$400–500	$300–350	$275–325
428-8" bowl	$400–500	$300–350	$275–325
429-10" bowl	$500–600	$400–500	$350–450
430-12" tray	$475–550	$375–450	$300–375
431-15" bowl, canoe			
shape (I/203)	$600–700	$500–600	$450–550
432-12" bowl (I/204)	$500–600	$400–500	$350–400
433-12" bowl, based			
on Pine Cone			
322-12" bowl	$500–600	$400–500	$350–400
441-4" rose bowl			
(I/204)	$275–350	$225–275	$175–225
451-4" candlestick			
(I/203) (pr)	$400–500	$350–400	$300–375
454-7" planter,			
bathtub shape	$375–450	$325–375	$275–350
455-6" planter	$250–300	$200–250	$175–200
456-6" planter	$275–325	$225–275	$175–225
457-7" planter	$375–450	$325–375	$275–350
458-5" planter			
(I/203)	$375–450	$325–375	$275–325
458F-5" planter			
(I/203)	$400–500	$350–400	$300–350
459-8" combination			
bookend and			
planter (pr)	$750–950	$600–700	$500–600
461 hanging basket	$600–700	$475–550	$450–500

	Blue	Brown	Green
462 double serving tray (I/204)	$500–600	$400–500	$350–425
466 triple wall pocket	$850–1000	$600–700	$500–600
468-8" window box	$375–450	$300–350	$250–300
469-12" window box	$700–800	$500–600	$450–550
472-6" fan vase	$375–450	$300–375	$275–325
473-8" double vase (I/203)	$450–550	$375–450	$300–400
479-7" bud vase, based on Pine Cone 112-7" bud vase **(I/21)**	$200–250	$175–200	$175–200
480-7" vase, based on Pine Cone 841-7" vase	$425–475	$350–400	$300–350
485-10" ewer (I/204)	$600–700	$500–600	$450–550
490-8" vase (I/203)	$500–600	$450–500	$375–450
491-10" vase	$700–800	$550–650	$500–600
492-12" gladiola vase	$1000–1200	$850–1000	$750–850
493-12" vase, based on Pine Cone 911-12" vase	$850–1000	$750–850	$650–750
497 candy dish	$225–275	$175–225	$175–225
498 cigarette holder	$300–350	$275–300	$250–275
499 ashtray	$200–250	$175–225	$150–200
1499 hostess set, consisting of 497 candy dish, 498 cigarette holder, and two 499 ashtrays, originally a boxed set	$850–1000	$750–900	$650–800

*Comprehensive shape list (see page 12)

*POPPY

NOTE: Add 25–50% for brown.

35 flower frog (I/8)	$125–150
334-4" rose bowl (I/205)	$150–200
335-6" rose bowl	$175–225
336-5" bowl	$150–200
337-8" bowl	$175–225
338-10" bowl	$225–275
339-12" bowl	$275–325
340-14" bowl	$325–375
341-7" centerpiece (I/205)	$300–350
347-10" basket (I/205)	$400–500
348-12" basket (I/205)	$500–600
358-5" hanging basket	$300–350
642-4" jardiniere	$150–200
642-5" jardiniere	$200–250
642-6" jardiniere	$300–400
642-7" jardiniere	$400–500
642-8" jardiniere and pedestal	$1000–1200
642-10" jardiniere and pedestal	$1200–1500
643-5" flower pot and saucer	$250–300
866-6" vase	$175–225
867-6" vase (I/206)	$175–225
868-7" vase	$250–300
869-7" vase	$275–325
870-8" pillow vase	$300–350
871-8" vase	$275–325
872-9" vase	$300–400
873-9" vase (I/205)	$275–350
874-10" vase	$375–450
875-10" vase	$375–450
876-10" ewer	$450–550
877-12" vase	$500–600
878-15" vase	$800–900
879-18" floor vase (I/205)	$1000–1200
880-18" ewer	$850–1000
1129 candlestick (I/206) (pr)	$225–275
1130-5" candlestick (I/205)	$95–125
1281-8" wall pocket	$700–800

*Comprehensive shape list (see page 12)

22-4" flower frog	$150–200
125-6" cornucopia (I/207)	$95–125
260-5" fern dish	$150–200
284-4" rose bowl	$125–175
285-6" rose bowl	$150–200
286-9" bowl	$125–175
287-12" x 7" bowl	$200–250
341-10" basket	$325–375
354-5" hanging basket (I/207)	$350–450
381-10" window box	$500–600
634-4" jardiniere	$125–150
634-5" jardiniere	$150–175
634-6" jardiniere	$200–250
634-7" jardiniere	$300–400
634-8" jardiniere	$500–600
634-8" jardiniere and pedestal	$1200–1400
634-9" jardiniere	$650–750
634-10" jardiniere and pedestal	$1500–1800
636-5" flower pot and saucer	$250–300
760-6" vase	$150–200
761-6" vase	$150–200
762-7" vase	$175–225
763-7" vase	$175–225
764-7" vase (I/207)	$175–225
765-8" pillow vase (I/207)	$250–300
766-8" vase	$250–300
767-8" vase (I/27/1/2)	$250–300
768-9" vase	$300–400
769-9" vase	$300–400
770-10" vase (I/206)	$350–450
771-12" vase (I/206)	$500–600
772-14" vase	$650–750
772-14" x 10" sand jar	$850–1000
773-21" x 10" umbrella stand	$1000–1200
1105-4.5" candlestick (I/207)	$95–125
1113-5.5" triple candelabra	$225–275
1277-8" wall pocket	$750–850

*Comprehensive shape list (see page 12)

*RAYMOR MODERN ARTWARE

18-23" basket	$750–1000
26-16" bowl (I/208)	$400–500
27-21" bowl	$300–350
28-8" bowl (I/208)	$175–225
29-11" bowl, clam shape (I/207)	$500–600
41-6" rose bowl, toaster shape	$450–550
52-2.25" x 14.75" candelabra	$225–275
61-11" pillow vase	$500–600
62-12" pillow vase	$650–750
63-7" vase	$350–450
65-13" vase, clam-shaped opening	$600–700
66-15" vase	$700–800
67-21" floor vase	$1200–1500
68-11" jardiniere	$700–800
88 pen and pencil holder	$200–250
94 ashtray	$100–125
95 ashtray	$100–125
96 cigarette box, metal lid (I/208)	$200–250
97 cigarette holder	$150–200
98-6" ashtray	$125–150
99-8" ashtray	$125–150
5" d. candlesticks, round (I/208/1/1) (pr)	$350–450
5.25" humidor, metal lid	$300–400
9.25" x 4.25" triangular divided tray, metal legs (I/208/2/2)	$250–300
bookends	NPD
cigarette dispenser, metal holder	NPD
letter holder, metal legs	NPD
paperweight, metal ring	NPD
desk-top box, metal lid	NPD

*Comprehensive shape list (see page 12)

*RAYMOR MODERN STONEWARE

NOTE: Add 25–50% for blue.

150 cup	$20–25
151 saucer	$10–15
152 dinner plate	$25–30
153 salad plate	$20–25
154 bread and butter plate	$10–15
155 lug soup	$25–30
156 individual covered ramekin (I/209)	$40–50
157 covered sugar (I/209/3/2)	$40–50
158 covered cream pitcher (I/209)	$40–50
159 stand for sugar and creamer	$40–50
160 vegetable bowl	$30–40
161 salad bowl	$35–45
162 individual corn server	$25–30
163 platter	$75–100
164 chop platter	$50–75
165 divided vegetable bowl	$125–150
166 handled fruit bowl	$150–175
167 6-pc. condiment set (items 168–173)	$250–300
168 salt shaker	$20–30
169 pepper shaker	$20–30
170 vinegar cruet	$40–50
171 oil cruet	$40–50
172 covered jam or relish, with spoon	
	without spoon, $40–50
	with spoon $60–75
173 condiment stand only	$50–60
174 tea pot	$200–250
175 tea pot trivet	$50–60
176 large coffee pot and stand	$350–450
177 celery and olive dish	$125–150
178 steak platter with well	$150–175
179 handled coffee tumbler	$40–50
180 3-pc. cheese and relish set (181 and 182)	$250–300
181 covered butter dish	$60–75
182 relish and sandwich tray	$150–175
183 medium casserole	$100–125
184 medium casserole trivet	$40–50
185 large casserole	$125–175
186 large casserole trivet	$50–60
187 4-qt. bean pot	$150–200
188 bean pot trivet	$50–60
189 water pitcher (I/209)	$125–175
190 gravy boat	$60–75
191 pickle dish	$35–45
192 lug fruit	$20–25
193 3-qt. bean pot	$125–150
194 2-qt. bean pot	$100–125
195 individual bean pot	$60–75
196 4-qt. handled casserole	$150–175
197 2.5-qt. handled casserole	$125–150
198 1.5-qt. handled casserole	$100–125
199 individual casserole	$50–60
200 shirred egg	$50–60
201 double stacked warmer	$100–125

*RAYMOR MODERN STONEWARE *(cont.)*

202 bun warmer $250–300
203 ash tray $40–50
300 16-pc. starter set (four 150 cups, four 151
 saucers, four 152 dinner plates,
 and four 154 bread and
 butter plates) without box, $275–350
 in original box, $400–$500

**Set, four 156 individual covered ramekins
in wire and raffia stand,
assorted colors (I/209/3/1)** $275–$350

*Comprehensive shape list (see page 12)

134

*RAYMOR TWO-TONE CASUAL

9 mixing bowl, 1-qt.	$50–75
10 mixing bowl, 1.5-qt.	$75–100
11 mixing bowl, 3-qt.	$100–150
12 mixing bowl, 5-qt.	$150–200
14 pitcher, 1-pt.	$75–100
15 pitcher, 1-qt.	$100–125
16 pitcher, 2-qt.	$150–175
17 pitcher, 2.5-qt.	$200–250
18 covered baking dish, 2.5-qt. (I/210)	$150–200
19 covered baking dish, 5-qt.	$100–150
20 covered casserole, 2-qt. (I/210)	$175–225
21 covered casserole, 5-qt.	$175–225
22 covered casserole, 2-pt.	$100–150

*Comprehensive shape list (see page 12)

ROSECRAFT

15-3.5" flower block (I/212)	$20–25
44-8" bud vase (I/212)	$125–150
74-8" bowl (I/212)	$95–125
129-5" rose bowl (I/212)	$125–150
175-6" vase, also a Lustre shape **(I/212)**	$125–175
180-10" vase (I/35)	$250–300
182-12" vase (I/212)	$275–325
223-5.5" vase (I/212)	$125–175
225-12" vase (I/212)	$200–250
244-6" vase (I/212)	$125–175
248-8" vase (I/212)	$150–200
311-7" vase, also a Carnelian shape **(I/212)**	$150–200
316-9.5" basket (I/213)	$200–250
319-8" basket (I/212 and 213)	$175–225
319-10" vase, also a Carnelian shape **(I/212)**	$250–300
585-4" vase, an Ivory shape **(I/212)**	$95–125
1031-6" candlestick (I/211)	$50–60
1033-12" candlestick (I/211)	$75–95
1037-10" candlestick (Bomm/274/3/5; shape number 1039 in stock pages is probably a factory error) (pr)	$150–200
1038-10" candlestick (I/211) (pr)	$150–200

1214	*Unknown*	ca. 1916–1920
1215	Rozane Line	by 1920
1216	Vista	ca. 1920
1217	Dogwood (Smooth)	by 1920
1218–1220	*Unknown—probably Dogwood (Smooth)*	ca. 1920–1921
1221–1223	Imperial (Textured)	1921
1224	Mostique	1921
1225	Rosecraft	by 1921
1226–1227	Early Rosecraft	ca. 1922
1228–1229	Corinthian	1923
1230–1231	Florentine	1924
1232	Corinthian	1924
1233–1235	La Rose	1924
1236–1237	Rosecraft	ca. 1924–1925
1238–1239	Florentine	ca. 1924–1925
1240	Hexagon	1925
1241	Vintage	1925
1242–1243	*Unknown—probably Vintage and Panel*	ca. 1925–1926
1244	Panel	by 1926
1245	Dogwood (Textured)	1926
1246–1249	Carnelian	1926
1250	*Unknown*	ca. 1926–1927
1251–1253	Carnelian	ca. 1926–1927
1254–1255	Tuscany	1927
1256–1257	Lombardy	1928
1258–1259	Dahlrose	1929
1260	Savona	1929
1261	Futura	1929
1262	Imperial (Glazes)	1930
1263	Earlam/Imperial (Glazes)	1930
1264	Imperial (Glazes)	1930
1265	Sunflower	1930
1266	Ferella	1930
1267	Blackberry	ca. 1931–1932
1268	Jonquil	1932
1269	Baneda	1932
1270	Cherry Blossom	1933
1271	Wisteria	1933
1272	Luffa	1934
1273	Pine Cone	1935
1274	Velmoss	1935
1275	Morning Glory	1935
1276	Orian	1935
1277	Primrose	1936
1278–1279	Moss	1936
1280	Thorn Apple	1937
1281	Poppy	1938
1282	Fuchsia	1938
1283	Pine Cone	ca. 1938–1939
1284	Iris	1939
1285–1286	Cosmos	1939
1287	Bleeding Heart	1940
1288–1289	White Rose	1940
1290	Columbine	1941
1291	Bushberry	1941
1292	Foxglove	1942
1293	Peony	1942

723–732	Morning Glory	1935
733–743	Orian	1935
744	*Unknown*	ca. 1935–1936
745–748	Pine Cone	ca. 1935–1936
749–759	Clemana	1936
760–772	Primrose	1936
773–786	Moss	1936
787–803	Moderne	1936
804–807	Pine Cone	1937
808–825	Thorn Apple	1937
826–834	Dawn	1937
835	Thorn Apple	1937
836–837	Ivory/Crystal Green	1937
838–851	Pine Cone	1937
852–865	Ixia	1937
866–880	Poppy	1938
881–890	Teasel	1938
891–905	Fuchsia	1938
906–913	Pine Cone	ca. 1938–39
914–929	Iris	1939
930–943	Ivory/Crystal Green	1939
944–959	Cosmos	1939
960	Pine Cone	ca. 1939–40
961–977	Bleeding Heart	1940
978–995	White Rose	1940
996–1000	*Unknown*	
1001	Tulip figural vase	ca. 1940
1–11	Rozane Pattern	1941
12–27	Columbine	1941
28–41	Bushberry	1941
42–56	Foxglove	1942
57–70	Peony	1942
71–85	Water Lily	1943
86–100	Magnolia	1943
101	*Unknown*	ca. 1943–1944
102–103	Clematis	1944
104	*Unknown*	1944
105–112	Clematis	1944
113	*Unknown*	ca. 1944–1945
114	Clematis	ca. 1944–1945
115–116	*Unknown*	ca. 1944–1945
117–129	Freesia	1945
130–142	Zephyr Lily	1946

Wall Pockets

Shape Number	Line Name(s)	Year Shape(s) Introduced
1201–1204	Matt Green/Old Ivory (Tinted)	by 1916
1205–1207	Matt Green	by 1916
1208	Antique Matt Green	by 1916
1209	Antique Matt Green/Creamware (Tourist)	ca. 1916
1210–1211	Antique Matt Green	by 1916
1212	Donatello	by 1916
1213	Antique Matt Green	by 1916

331–334	Carnelian	ca. 1926–1927
335–339	Carnelian/Rosecraft	ca. 1926–1927
340	Carnelian	ca. 1926–1927
341–349	Tuscany	1927
350	Lombardy	1928
351–362	Cremona	1928
363–370	Dahlrose	1928
371–379	Savona	1929
380–412	Futura	1929
413–414	*Unknown*	ca. 1929
415	Donatello	ca. 1929
416	*Unknown*	ca. 1929
417	Donatello	ca. 1929
418	*Unknown*	ca. 1929
419–420	Dahlrose	ca. 1929
421–438	Futura	ca. 1929
439–450	Carnelian	ca. 1929
451	*Unknown—perhaps Carnelian*	ca. 1929
452–461	Carnelian	ca. 1929
462–463	*Unknown*	ca. 1929
464	Dahlrose	ca. 1929
465	*Unknown*	ca. 1929
466–484	Imperial (Glazes)	1930
485–494	Sunflower	1930
495	*Unknown*	1930
496	Dahlrose	1930
497–511	Ferella	1930
512–514	Sunflower	1930
515–522	Earlam	1930
523–531	Jonquil	ca. 1930
532–537	Mostique	1931
538–544	Jonquil	1931
545–554	Windsor	1931
555–565	Montacello	1931
566	Sunflower	ca. 1931–1932
567–578	Blackberry	ca. 1931–1932
579	Montacello	ca. 1931–1932
580–581	Jonquil	ca. 1931–1932
582–583	Windsor	ca. 1931–1932
584	*Unknown—probably Windsor 15" vase*	ca. 1931–1932
585–586	Ivory	1932
587–606	Baneda	1932
607–609	Solid Colors	1932
610	Baneda	ca. 1932–1933
611–616	Tourmaline	1933
617–628	Cherry Blossom	1933
629–641	Wisteria	1933
642–655	Falline	1933
656–666	Topeo	1934
667–678	Laurel	1934
679	Ivory/Tourmaline	1934
680–682	Wisteria	1934
683–693	Luffa	1934
694–703	Russco	1934
704–709	Pine Cone	1935
710	*Unknown*	1935
711–713	Pine Cone	1935
714–722	Velmoss	1935

118	Donatello	by 1916
119–124	*Unknown*	by 1916
125–140	Early Velmoss	by 1916
102	Rozane Line	by 1920
R108–R110	Rozane Line	by 1920
120–127	Vista	ca. 1920
128	*Unknown—probably Vista*	ca. 1920
129–134	Vista	ca. 1920
135–140	Dogwood (Smooth)	by 1920
141–149	*Unknown*	ca. 1920–1921
150–152	Imperial (Textured)	1921
153	*Unknown*	1921
154	*Unknown—probably Imperial (Textured)*	1921
155	*Unknown*	1921
156	Imperial (Textured)	1921
157–161	*Unknown*	1921
162–163	Imperial (Textured)	1921
164	Mostique	1921
165–168	Rosecraft	by 1921
169–179	Lustre	by 1922
180–183	Rosecraft	ca. 1921–1922
184	Donatello	ca. 1922
185–187	Rosecraft	1922
188–192	Volpato	1922
193–205	Early Rosecraft	1922
206–209	Volpato	1922
210–211	Rosecraft	ca. 1922–1923
212–220	Corinthian	1923
221	*Unknown*	ca. 1923
222	Volpato	1923
223	Rosecraft	ca. 1923–1924
224	*Unknown*	ca. 1923–1924
225	Rosecraft	ca. 1923–1924
226	*Unknown*	ca. 1923–1924
227	Rosecraft/Lustre	ca. 1923–1924
228–234	Florentine	1924
235	Corinthian	1924
236–243	La Rose	1924
244–245	Rosecraft	1924
246	Rosecraft (see Bomm 274/4/2; the 244 is believed to be a factory error)	1924
247–251	Rosecraft	1924
252–255	Florentine	1924
256–265	Victorian Art Pottery	ca. 1924–1925
266–272	Hexagon	1925
273–280	Vintage	1925
281–284	*Unknown*	ca. 1925–1926
285	Panel	by 1926
286–290	*Unknown*	ca. 1926
291–299	Panel	by 1926
300–305	Dogwood (Textured)	1926
306–307	Carnelian	1926
308–309	Carnelian/Rosecraft	1926
310	Carnelian	1926
311	Carnelian/Rosecraft	1926
312–313	Carnelian	1926
314–319	Carnelian/Rosecraft	1926
320–322	Carnelian	1926
323–330	*Unknown*	ca. 1926–1927

3	Peony	1942
4	Magnolia	1943
5	Clematis	1944
6	Freesia	1945
7	Zephyr Lily	1946

Umbrella Stands, Sand Jars

Shape Number	Line Name(s)	Year Shape(s) Introduced
740	Matt Green	by 1916
741	Antique Matt Green/Matt Green	by 1916
742	Antique Matt Green/Early Carnelian	by 1916
743–749	Decorated Artware	by 1916
750	Sylvan	ca. 1916
751	*Unknown*	1916
752	Mostique	by 1916
753	Donatello	by 1916
754	Early Velmoss	by 1916
755	*Unknown*	ca. 1916–1920
756	Rozane Line	by 1920
757	Vista	ca. 1920
758	Dogwood (Smooth)	by 1920
759	Imperial (Textured)	1921
760	*Unknown*	ca. 1921–1924
761	La Rose	1924
762	*Unknown*	1924
763–764	Florentine	1924
765	*Unknown*	ca. 1924–1926
766	Dogwood (Textured)	1926
767	*Unknown–probably Normandy*	ca. 1926–1928
768	Normandy	ca. 1928
769	Earlam	1930
770	Sunflower	1930
771	Luffa	1934
772–773	Primrose	1936
774–775	Thorn Apple (floor vases)	1936
776–777	Pine Cone	1936
778–779	Bushberry	1941

Vases (and pre-1941 Ewers)

Shape Number	Line Name(s)	Year Shape(s) Introduced
1–32	Early Carnelian	by 1916
33–39	Early Carnelian	by 1916
33–39 (different)	Early Carnelian	by 1916
40–46	Early Carnelian	by 1916
47–52	*Unknown—perhaps not assigned to vase shapes*	
53–54	Early Carnelian	by 1916
55–100	*Unknown—perhaps not assigned to vase shapes*	
1–30	Mostique	by 1916
101–116	Donatello	by 1916
117	*Unknown*	by 1916

186

120	Morning Glory	1935
121	Pine Cone	1935
122–123	Clemana	1936
124	Pine Cone	1936
125	Primrose	1936
126	Pine Cone	ca. 1936–1937
127	Thorn Apple	1937
128	Pine Cone	ca. 1937–1938
129	Fuchsia	1938
130–132	Iris	1939
133–137	Cosmos	1939
138–142	Bleeding Heart	1940
143–148	White Rose	1940
149–151	Columbine	1941
152–158	Bushberry	1941
159–166	Foxglove	1942
167–173	Peony	1942
174–178	Water Lily	1943
179–186	Magnolia	1943
187–188	Clematis	1944
189	*Unknown*	1944
190–194	Clematis	1944
195–200	Freesia	1945
201–206	Zephyr Lily	1946

Pitchers

Shape Number	Line Name(s)	Year Shape(s) Introduced
1303–1306	Creamware (Persian)	ca. 1916
1307	Donatello	by 1916
1308	*Unknown*	by 1916
1309	Utility Ware (Banded)	ca. 1924
1310	*Unknown* ·	ca. 1924–1926
1311–1316	Carnelian	1926
1317	*Unknown*	ca. 1926–early 1930s
1318–1320	Utility Ware (Lilies of the Valley)	ca. early 1930s
1321	Pine Cone	1938
1322	Fuchsia	1938
1323	Bleeding Heart	1940
1324	White Rose	1940
1325	Bushberry	1941
1326	Peony	1942
1327	Magnolia	1943

Tea Sets

Shape Number	Line Name(s)	Year Shape(s) Introduced
1	White Rose	1940
2	Bushberry	1941
3	Peony	1942
4	Magnolia	1943
5	Clematis	1944
6	Freesia	1945
7	Zephyr Lily	1946

Mugs

Shape Number	Line Name(s)	Year Shape(s) Introduced
1	Bushberry	1941
2	Peony	1942
3	Magnolia	1943

Novelties (Bud Vases, Cornucopias, Double Bud Vases or "Gates," Fan Vases, Flower Frogs, Strawberry Jars, etc.)

Shape Number	Line Name(s)	Year Shape(s) Introduced
1–7	Matt Green	ca. 1916
8–9	Donatello	by 1916
10	Matt Green	by 1916
11	*Unknown*	by 1916
12–13	Early Carnelian	by 1916
14	*Unknown*	by 1916
15–18	Early Carnelian	by 1916
19–28	*Unknown*	ca. 1916
S33–S42	Sylvan	ca. 1916
29–31	Imperial (Textured)	1921
32–33	Rosecraft	by 1921
34–35	Lustre	by 1922
36	Donatello	by 1916
37	Corinthian	1923
38–39	*Unknown*	ca. 1923–1924
40–41	Florentine	1924
42	Corinthian	1924
43	La Rose	1924
44–46	Rosecraft	ca. 1924–1925
47	Hexagon	1925
48	Vintage	1925
49	*Unknown—probably Panel (gate)*	ca. 1925–1926
50–65	Carnelian	ca. 1926–1927
66–71	Tuscany	1927
72–75	Cremona	1928
76–79	Dahlrose	1928
80	Tuscany	1928
81–82	Futura	1928
83–84	*Unknown*	ca. 1928–1929
85	Futura	ca. 1928–1929
86	*Unknown*	ca. 1928–1929
87	Ferella	1930
88–92	Earlam	1930
93–98	Jonquil	ca. 1930
99–100	Mostique	1931
101–102	*Unknown*	ca. 1931–1932
103	Ivory/other (covered jar)	ca. 1933
104	*Unknown*	ca. 1933

608	Dogwood (Textured)	1926
609	Normandy	ca. 1927
610–612	Garden Pottery	1927
613	Lombardy	1928
614	Dahlrose	1928
615	Tuscany	1928
616	Futura	1928
617	Donatello	ca. 1928–1930
618	*Unknown–probably Dahlrose*	ca. 1928–1930
619	Sunflower	1930
620	Ferella	1930
621	Jonquil	ca. 1930
622	Mostique	ca. 1931
623	Blackberry	ca. 1931–1932
624–625	Solid Colors	ca. 1932
626	Baneda	1932
627	Cherry Blossom	1933
628	Wisteria	1933
629	Artcraft	1933
630	Ivory	ca. 1933–1934
631	Luffa	1934
632–633	Pine Cone	1935
634	Primrose	1936
635	Moss	1936
636	Primrose	1936
637	Moss	1936
638–639	Thorn Apple	1937
640–641	Ixia	1937
642–643	Poppy	1938
644	Teasel	1938
645–646	Fuchsia	1938
647–648	Iris	1939
649–650	Cosmos	1939
651–652	Bleeding Heart	1940
653–654	White Rose	1940
655–656	Columbine	1941
657–658	Bushberry	1941
659–660	Foxglove	1942
661–662	Peony	1942
663–664	Water Lily	1943
665–666	Magnolia	1943
667–668	Clematis	1944
669–670	Freesia	1945
671–672	Zephyr Lily	1946

Miscellaneous

Shape Number	Line Name(s)	Year Shape(s) Introduced
1 (fruit bowl)	Rozane Line	by 1920
1 (dog)	Ivory	1936
1–2 (ornaments)	Rozane Pattern	1941
6 (bowl)	Clematis	1944

463	White Rose	1940
464	Columbine	1941
465	Bushberry	1941
466	Foxglove	1942
467	Peony	1942
468	Water Lily	1943
469	Magnolia	1943
470	Clematis	1944
471	Freesia	1945
472	Zephyr Lily	1946

Jardinieres, Flower Pots

Shape Number	Line Name(s)	Year Shape(s) Introduced
548–549	Matt Green	by 1916
550	Antique Matt Green/Early Carnelian	by 1916
551-556	*Unknown*	by 1916
557	Creamware	by 1916
558	Matt Green/Antique Matt Green	by 1916
559	Matt Green	by 1916
560	Antique Matt Green	by 1916
561-563	*Unknown*	by 1916
564	Majolica	by 1916
565	Antique Matt Green	by 1916
566-567	*Unknown*	by 1916
568	Sylvan	1916
569	Creamware (Tourist)	by 1916
570	*Unknown*	by 1916
571	Mostique	by 1916
572	*Unknown*	by 1916
573	Mostique	by 1916
574	Early Carnelian	by 1916
575	Donatello	by 1916
576	*Unknown*	by 1916
577–578	Early Velmoss	by 1916
579–580	Donatello	by 1916
581–583	Early Carnelian	by 1916
584–587	*Unknown*	ca. 1916–1920
588	Rozane Line	by 1920
589	Vista	ca. 1920
590	Dogwood (Smooth)	by 1920
591	Imperial (Textured)	1921
592–593	Mostique	1921
594–597	*Unknown*	ca. 1921
598	Rosecraft	by 1921
599	Volpato	1922
600	Early Rosecraft	ca. 1922
601	Corinthian	1923
602	Florentine	1924
603	Corinthian	1924
604–605	La Rose	1924
606	Mostique	ca. 1924–1925
607	Vintage	1925

37	Fuchsia	1938
38	Iris	1939
39	Cosmos	1939
40	Bleeding Heart	1940
41	White Rose	1940
42	Columbine	1941
43	*Unknown—perhaps Ivory*	1941
44	Rozane Pattern	1941
45	Bushberry	1941
46	Foxglove	1942
47	Peony	1942
48	Water Lily	1943
49	Magnolia	1943
50	Clematis	1944

Hanging Baskets

Shape Number	Line Name(s)	Year Shape(s) Introduced
325	Sylvan	by 1916
326	*Unknown*	by 1916
327	Donatello	by 1916
328–329	*Unknown*	by 1916
330	Rozane Line	by 1920
331	Vista	ca. 1920
332	*Unknown-probably Dogwood (Smooth)*	ca. 1920–1921
333	Imperial (Textured)	1921
334	Mostique	ca. 1921–1922
335	Early Rosecraft	ca. 1922
336	Corinthian	1923
337	Florentine	1924
338	La Rose	1924
339	Florentine	ca. 1924–1926
340	Dogwood (Textured)	1926
341	Normandy	ca. 1928
342	Lombardy	ca. 1928
343	Dahlrose	by 1928
344	Futura	1928
345	*Unknown*	ca. 1928–1930
346	Sunflower	1930
347	Earlam	1930
348	Blackberry	ca. 1931–1932
349	Jonquil	ca. 1931–1932
350	Cherry Blossom	1933
351	Wisteria	1933
352	Pine Cone	1935
353	Moss	1936
354	Primrose	1936
355	Thorn Apple	1937
356	Thorn Apple (wall pocket, flower pot shape)	1937
357	Ixia	1937
358	Poppy	1938
359	Fuchsia	1938
360	Iris	1939
361	Cosmos	1939
362	Bleeding Heart	1940

244	Rozane Line	ca. 1920
245-248	*Unknown*	ca. 1920
249	Vista	ca. 1920
250	Rozane Line	by 1920
251–252	Imperial (Textured)	1921
253	Mostique	by 1916
254	Early Rosecraft	ca. 1922
255–256	Corinthian	1923
257–258	Florentine	1924
259	La Rose	1924
260	Primrose	1936
261	Pine Cone	1935
262	Thorn Apple	1937

--

Flower Frogs

Shape Number	Line Name(s)	Year Shape(s) Introduced
12–13	Early Carnelian	by 1916
14	Donatello	by 1916

NOTE: The #14 frog (made in two sizes) was later glazed to complement Corinthian (1923) and La Rose (1924). Probably in 1932, it was made in Ivory.

| 15 | Mostique | by 1916 |

NOTE: The #15 frog (made in two sizes) was glazed to coordinate with many Roseville lines—including Early Carnelian and Early Velmoss (both ca. 1916), Sylvan (by 1920), Rosecraft (1921), Lustre (1922), Florentine (1924), Carnelian (1926), Tuscany (1927), Lombardy (1928), Futura (1928), Savona (1929), Ferella (1930), Earlam (1930), Jonquil (ca. 1930–1931), Ivory (1932) and Russco (1934).

16	*Unknown*	
17–18	Early Carnelian	
17	Carnelian	1926

NOTE: The #17 "Carnelian" frog (made in two sizes) was glazed to coordinate with at least three later lines—Ivory (1932), Tourmaline (1933) and Luffa (1934).

20–21	Pine Cone	1935
22	Primrose	1936
23	Clemana	1936
24–25	Moss	1936
26–27	Moderne	1936
28	Ivory	ca. 1936–37
29–30	Thorn Apple	1937
31	Dawn	1937
32–33	Pine Cone	1937
34	Ixia	1937
35	Poppy	1938
36	Teasel	1938

Covered Vases and Bowls

Shape Number	Line Name(s)	Year Shape(s) Introduced
1–2	Donatello	by 1916
3	Volpato	1922
4	Rosecraft	by 1921
5	Volpato	1922

Cuspidors

Shape Number	Line Name(s)	Year Shape(s) Introduced
615	Decorated Artware (Blue Porcelain)	by 1916
616–620	*Unknown*	by 1916
621	Old Ivory (Tinted)	by 1916
622–625	*Unknown*	by 1916
626	Rozane Royal (Home Art)/Matt Green	by 1916
627	Majolica/Matt Green	by 1916
628	Donatello	by 1916
629–630	*Unknown—one probably Rozane Line*	by 1916
631	Mostique	by 1916
909	Rozane Royal (Home Art)/Matt Green/Creamware (Tourist)	by 1916

Ewers (1941–1946)

Shape Number	Line Name(s)	Year Shape(s) Introduced
1–3	Bushberry	1941
4–6	Foxglove	1942
7–9	Peony	1942
10–12	Water Lily	1943
13–15	Magnolia	1943
16–18	Clematis	1944
19–21	Freesia	1945
22–24	Zephyr Lily	1946

Fern Dishes

Shape Number	Line Name(s)	Year Shape(s) Introduced
225	Sylvan	ca. 1916
226	Antique Matt Green/Creamware (Tourist)	by 1916
227–232	Donatello	by 1916
233–235	*Unknown*	by 1916
236	Early Carnelian	by 1916
237–238	Donatello	by 1916
239–243	*Unknown*	ca. 1916–1920

Compotes, Footed Fern Dishes

Shape Number	Line Name(s)	Year Shape(s) Introduced
1–2	Rozane Line	by 1920
3–4	Rosecraft	by 1921
5–8	Lustre	by 1922
9	Donatello	ca. 1922
10–11	Rosecraft	ca. 1922
12	Volpato	1922
13	*Unknown*	1922
14	Early Rosecraft	1922
15	Corinthian	1923
2	Volpato	1922
6–7	Florentine	1924
8	Hexagon	1925
9	Vintage	1925
10–12	*Unknown*	ca. 1925
13-14	Savona	1929
15–16	*Unknown—one probably Mostique (see Bassett I/11)*	ca. 1925
17	Florentine	ca. 1925
1	Bushberry	1941
2	Foxglove	1942
3–4	Peony	1942
5	Magnolia	1943
6	Clematis	1944
7	Freesia	1945
8	Zephyr Lily	1946

Cookie Jars

Shape Number	Line Name(s)	Year Shape(s) Introduced
1	Water Lily	1943
2	Magnolia	1943
3	Clematis	1944
4	Freesia	1945
5	Zephyr Lily	1946

Cornucopias (1940–1941)

Shape Number	Line Name(s)	Year Shape(s) Introduced
1	White Rose	1940
2	Rozane Pattern	1941
3	Bushberry	1941

1070–1071	Savona	1929
1072–1073	Futura	1929
1074	*Unknown*	ca. 1929
1075	Futura	ca. 1929
1076–1077	Imperial (Glazes)	1930
1078	Ferella	1930
1079	Sunflower	1930
1080–1081	Earlam	1930
1082	Jonquil	ca. 1930
1083	Mostique	1931
1084	Windsor	1931
1085	Montacello	1931
1086	Blackberry	ca. 1931–1932
1087–1088	Baneda	1932
1089	Tourmaline	1933
1090	Cherry Blossom	1933
1091	Wisteria	1933
1092	Falline	1933
1093	Topeo	1934
1094	Laurel	1934
1095	Topeo/Ivory	1934
1096	Ivory	1934
1097	Luffa	1934
1098	Russco	1934
1099C	Pine Cone	1935
1100	Velmoss	1935
1101	Russco	1935
1102	Morning Glory	1935
1103	Orian	1935
1104	Clemana	1936
1105	Primrose	1936
1106	Pine Cone	1936
1107–1109	Moss	1936
1110–1112	Moderne	1936
1113	Primrose	ca. 1936–37
1114–1116	Ivory/Crystal Green	ca. 1936–37
1117–1120	Thorn Apple	1937
1121	Dawn	1937
1122	Ivory/Crystal Green	1937
1123–1124	Pine Cone	1937
1125–1128	Ixia	1937
1129–1130	Poppy	1938
1131	Teasel	1938
1132–1133	Fuchsia	1938
1134–1135	Iris	1939
1136–1137	Cosmos	1939
1138	Ivory	1939
1139–1140	Bleeding Heart	1940
1141–1143	White Rose	1940
1144	Rozane Pattern	1941
1145–1146	Columbine	1941
1147–1148	Bushberry	1941
1149–1150	Foxglove	1942
1151–1153	Peony	1942
1154–1155	Water Lily	1943
1156–1157	Magnolia	1943
1158–1159	Clematis	1944
1160–1161	Freesia	1945
1162–1163	Zephyr Lily	1946

346–353	Fuchsia	1938
354–356	Pine Cone	ca. 1938–39
357–364	Iris	1939
365–368	Ivory/Crystal Green	1939
369–376	Cosmos	1939
377–384	Bleeding Heart	1940
385	Ivory (and perhaps Crystal Green)	1940
386	*Unknown*	1940
387–394	White Rose	1940
395–398	Rozane Pattern	1941
399–406	Columbine	1941
407–410	Rozane Pattern	1941
411–412	Bushberry	1941
413	*Unknown*	ca. 1941–42
414–417	Bushberry	ca. 1941–42
418–426	Foxglove	1942
427–436	Peony	1942
437–445	Water Lily	1943
446–454	Magnolia	1943
455–461	Clematis	1944
462	*Unknown*	ca. 1944–45
463–469	Freesia	1945
470–479	Zephyr Lily	1946

Candlesticks, Candelabra

Shape Number	Line Name(s)	Year Shape(s) Introduced
1004	Matt Green/Creamware (Persian or Holly)	by 1916
1005–1006	Matt Green	by 1916
1007	Creamware (Persian)	by 1916
1008–1009	Donatello	by 1916
1010	Matt Green	by 1916
1011	Donatello	by 1916
1012–1014	Early Carnelian	by 1916
1015	*Unknown*	ca. 1916–1920
1016	Rozane Line	by 1920
1017–1018	Rosecraft	by 1921
1019–1021	Lustre	by 1922
1022	Donatello	ca. 1922
1023–1028	Lustre	ca. 1922
1029–1038	Rosecraft	ca. 1922
1039–1043	Volpato	1922
1044–1045	Early Rosecraft	1922
1046–1047	Volpato	1922
1048	Corinthian	1923
1049–1050	Florentine	1924
1051–1052	La Rose	1924
1053–1056	*Unknown*	ca. 1924–26
1057	Panel	by 1926
1058–1060	Carnelian	1926
1061	*Unknown*	ca. 1926–28
1062	Florentine	ca. 1926–28
1063–1065	Carnelian	ca. 1926–28
1066–1067	Tuscany	1928
1068	Cremona	1928

181	*Unknown*	ca. 1928–1929
182	*Unknown—perhaps Tuscany*	ca. 1928–1929
183–186	Savona	1929
187–191	Futura	1929
192	Donatello	ca. 1929–1930
193	*Unknown*	ca. 1929–1930
194–198	Futura	ca. 1929–1930
199–207	Imperial (Glazes)	1930
208	Sunflower	1930
209	Dahlrose	1930
210–212	Ferella	1930
213	Sunflower	1930
214–216	*Unknown—perhaps Sunflower*	1930
217–218	Earlam	1930
219–220	Jonquil	ca. 1930
221–222	Mostique	1931
223	Jonquil	1931
224	Windsor	1931
225	Montacello	1931
226–228	Blackberry	ca. 1931–1932
229–231	*Unknown—perhaps Windsor*	1932
232–235	Baneda	1932
236	Solid Colors	1932
237	Baneda	1932
238	Ivory/Tourmaline	ca. 1932–33
239–240	Cherry Blossom	1933
241	Tourmaline	1933
242–243	Wisteria	1933
244	Falline	1933
245–246	Topeo	1934
247–248	*Unknown—perhaps Topeo*	1934
249	Topeo	1934
250–253	Laurel	1934
254	Wisteria	1934
255	Luffa	1934
256	*Unknown—perhaps Wisteria*	1934
257–258	Luffa	1934
259–260	Russco	1934
261–263	Pine Cone	1935
264–266	Velmoss	1935
267	Ivory	1935
268–271	Morning Glory	1935
272–275	Orian	1935
276	Pine Cone	1935
277	Ivory	1935
278–279	Pine Cone	1935
280–283	Clemana	1936
284–287	Primrose	1936
288	Pine Cone	1936
289–294	Moss	1936
295–302	Moderne	1936
303	Ivory/Crystal Green	ca. 1936–37
304–313	Thorn Apple	1937
314	Ivory/Crystal Green	1937
315–319	Dawn	1937
320–324	Pine Cone	1937
325–333	Ixia	1937
334–341	Poppy	1938
342–345	Teasel	1938

6	Bleeding Heart	1940
7	White Rose	1940
8	Columbine	1941
9	Bushberry	1941
10	Foxglove	1942
11	Peony	1942
12	Water Lily	1943
13	Magnolia	1943
14	Clematis	1944
15	Freesia	1945
16	Zephyr Lily	1946

Bowls, Centerpieces, Conch Shells, Trays

Shape Number	Line Name(s)	Year Shape(s) Introduced
40–52	Early Carnelian	by 1916
53–55	Donatello	by 1916
54–56	Early Velmoss	by 1916
57–58	*Unknown*	by 1916
59	Early Carnelian	by 1916
60–61	Donatello	by 1916
62	Early Carnelian	by 1916
63–65	*Unknown*	by 1916
66	Early Carnelian	by 1916
67–70	*Unknown*	ca. 1916–1921
71	Imperial (Textured)	by 1921
72–73	Mostique	ca. 1921
74–75	Rosecraft	by 1921
76–82	Lustre	by 1922
83	Rosecraft/Lustre	ca. 1921–1922
84–87	Lustre	ca. 1922
88–92	Donatello	ca. 1922
93–96	Rosecraft	ca. 1922
97–105	Volpato	1922
106–107	*Unknown*	1922
108–110	Rosecraft	1922
111–114	*Unknown*	1922
115–118	Early Rosecraft	1922
119–120	Volpato	1922
121	Corinthian	1923
122–123	*Unknown*	ca. 1923–1924
124	Rosecraft	ca. 1923–1924
125–126	Florentine	1924
127–128	La Rose	1924
129	Rosecraft	1924
130	Florentine	1924
131	Mostique	ca. 1924–1925
132–133	Victorian Art Pottery	ca. 1924–1925
134–138	Hexagon	1925
139–144	Vintage	1925
145–149	*Unknown—perhaps Panel*	ca. 1925–1926
150–151	Dogwood (Textured)	1926
152–170	Carnelian	1926
171–174	Tuscany	1927
175	Lombardy	1928
176–178	Cremona	1928
179–180	Dahlrose	1928

251–252	Rozane Line	by 1920
253–255	*Unknown*	1920
256–257	Vista	1920
258–259	*Unknown*	1920
260	Vista	1920
261-264	*Unknown*	1920
265	Dogwood (Smooth)	1920
266-290	*Unknown*	ca. 1920-21
291	Imperial (Textured)	1921
292-293	*Unknown-perhaps Imperial (Textured)*	ca. 1921-22
294-300	Lustre	1922
301–306	Donatello	ca. 1922–24
307–309	Lustre	ca. 1922–24
310	Lustre/Rosecraft	ca. 1922–24
311–312	Lustre	ca. 1922–24
313–319	Rosecraft	ca. 1922–24
320–322	Florentine	1924
323–328	Jonquil	ca. 1930
329–331	Windsor	1931
332–333	Montacello	1931
334–336	Blackberry	ca. 1931–1932
337	Russco	1934
338–339	Pine Cone	1935
340	Morning Glory	1935
341	Primrose	1936
342–343	Thorn Apple	1937
344	Ivory/Crystal Green	1937
345	Dawn	1937
346	Ixia	1937
347–348	Poppy	1938
349	Teasel	1938
350–351	Fuchsia	1938
352–353	Pine Cone	ca. 1938–39
354–355	Iris	1939
356	Ivory/Crystal Green	1939
357–358	Cosmos	1939
359–361	Bleeding Heart	1940
362–364	White Rose	1940
365–368	Columbine	1941
369–372	Bushberry	1941
373–375	Foxglove	1942
376–379	Peony	1942
380–382	Water Lily	1943
383–386	Magnolia	1943
387–389	Clematis	1944
390–392	Freesia	1945
393–395	Zephyr Lily	1946

Bookends

Shape Number	Line Name(s)	Year Shape(s) Introduced
1	Pine Cone	1935
2	Ivory/Crystal Green	ca. 1935–37
3	Thorn Apple	1937
4	Dawn	1937
5	Iris	1939

The Index also clarifies the original factory-designated "shape family" for hundreds of Roseville pieces. Only now can we distinguish window boxes from tall-sided console bowls. Rose bowls need no longer be confused with vases, nor fern dishes with low bowls. The ambiguous term "urn" can slip out of our vocabulary, since it was seldom used at the factory.

Finally, the Index explains an observation that has long puzzled collectors: *occasionally a shape number can refer to two completely unrelated shapes within the same line. These duplications occurred whenever the numbering sequences for two shape families happened to overlap.* Examples include the following:

- In Cherry Blossom, shape 627 corresponds to both a jardiniere and a 12" vase
- In Foxglove, shape 46 corresponds to both the flower frog and a 7" vase
- In Magnolia, shape 13 corresponds to both the bookend and a 6" ewer
- In Primrose, shape 772 corresponds to both a 14" vase and the sand jar.

The systems used to assign these shape numbers before 1916 and after 1946 will be discussed in my next book, *Understanding Roseville Pottery.* To be continued ...

Ashtrays

Shape Number	Line Name(s)	Year Shape(s) Introduced
15–17	Donatello	by 1916
18–20	Matt Green	by 1916
17	Florentine	1924
18–19	*Unknown*	
20	Imperial (Glazes)	1930
21	*Unknown—perhaps Imperial (Glazes)*	
22	Solid Colors	ca. 1932
23	*Unknown*	
24	Ivory	by 1935
25	Pine Cone	1935
26	Bushberry	1941
27	Peony	1942
28	Magnolia	1943
29	Zephyr Lily	1946

Baskets

Shape Number	Line Name(s)	Year Shape(s) Introduced
233	Donatello	by 1916
234	Early Carnelian	by 1916
235–250	*Unknown*	ca. 1916–20

Each gap in the numerical sequence is believed to represent a Roseville shape in that particular family—a design whose factory shape number has not yet been properly documented. Likewise, throughout *Bassett's Roseville Prices* the studious reader can locate items whose shape numbers are not yet known.

In many cases the Index provides clues to deciphering the hand-written shape numbers, which are sometimes difficult to read. For example, the Index shows that the Dahlrose flower pot is probably shape 618. Shape numbers for the Dogwood (Smooth) and Imperial (Textured) baskets should fall into the 200's. Because the shape dates to about 1939–40, we can expect the number 1138 to be a die-impressed (or raised-relief) mark on some as yet unidentified Roseville candlestick or candelabra.

Studying the Index reveals heretofore unknown dating information. Previous Roseville researchers have shown that by 1916 a variety of Mostique pieces in loosely related motifs were offered for sale (see Bomm, page 238, bottom; and 239). Whether these (or later) shapes were kept in production throughout the 1920s is still not known.

By means of this Index, we now know that additions were made to the Mostique line at three distinctly different times. In 1921 Roseville added to the Mostique line a group of items decorated either with arrowheads or with triangular stylized roses (see Bomm, page 236). In 1924 or 1925 a new group of bowls and jardinieres featured a highly abstract geometrical motif (see Bomm, page 237, top). In 1931 the final additions to the Mostique line—the now coveted high-gloss pots—depicted a diamond-shaped stylized flower (see Bomm, page 237, bottom; and 238, top).

Fortunately, the Index supports several conclusions that were made about dates in *Introducing Roseville Pottery.* Vista indeed appears to be a 1920 line. Victorian Art Pottery dates to 1925. As predicted, we can now confirm that Sunflower was introduced in 1930, Jonquil in ca. 1930–1931, and Blackberry in ca. 1931–1932.

On the other hand, the Index also corrects the presumed dates of introduction for several lines. The so-called "Early Rosecraft" line (inaccurately dubbed "Velmoss Scroll") must have appeared in 1922, not 1918 (as speculated in *Introducing Roseville Pottery*). Because the solid-colored line Rosecraft was introduced by 1921, the phrase "Early Rosecraft" now seems anachronistic as a name for the rose-decorated creamware line. Unfortunately, the actual name of this "Scottish Rose" line remains unknown. Until it is discovered, the nickname "Early Rosecraft" (or "Scottish Rose") will have to do.

Other corrections to the timetable follow: Sylvan probably dates to 1916, not 1920. Lombardy is a 1928 (not a 1926) line. Most of the shapes in the line "Solid Colors" (also known as "Matt Colors") were introduced around 1932—not 1916.

AN INDEX TO ROSEVILLE SHAPE NUMBERS, ca. 1916–1946

This Index demonstrates that, **between 1916 and 1946, nearly all Roseville shape numbers fit into specific numerical sequences—corresponding to each of over twenty-four different shape families.** The Roseville Pottery Company numbering system was discovered by long-time Roseville collector and researcher Lou Haggis, who also worked closely with me while preparing this Index for publication.

Someone at the Roseville Pottery must have used ledgers or card files to keep track of the various shape lists. Whenever needed, the next available shape number(s) in the appropriate sequence(s) would then be assigned to any new design(s) ready for production and marketing.

This numbering system was probably intended to ensure that unique numbers were assigned to new shapes. The procedure would also have simplified the task of locating a given plaster "master mold" when it was needed in order to cast additional "working molds." Over time, an unexpected side-effect of Roseville's use of these numerical sequences was that the shape numbers arranged themselves in chronological order, providing us with dating information not otherwise available today.

During this period nearly every Roseville shape was assigned to one of the following shape families:

ashtrays;
baskets;
bookends;
bowls, centerpieces, conch shells, and trays;
candlesticks;
compotes and footed fern dishes;
cookie jars;
covered vases and bowls;
cornucopias;
cuspidors;
ewers;
fern dishes;
flower frogs;
hanging baskets;
jardinieres and flower pots;
mugs;
novelties;
pitchers;
tea sets;
umbrella stands and sand jars;
vases;
wall pockets;
wall shelves; and
window boxes.

*ZEPHYR LILY

5-8" cookie jar (I/8)	$450–500
7-C creamer	$75–85
7-S sugar bowl	$75–85
7-T teapot	$275–350
8-10" compote	$175–200
16 bookend (I/264) (pr)	$250–300
22-6" ewer (I/264)	$125–175
23-10" ewer	$250–300
24-15" ewer (I/264)	$700–800
29 ashtray	$125–150
130-6" vase	$125–150
131-7" vase	$150–200
132-7" vase (I/264)	$150–200
133-8" vase	$175–200
134-8" vase	$175–225
135-9" vase	$200–225
136-9" vase	$200–250
137-10" vase (I/264)	$225–250
138-10" vase	$225–275
139-12" vase	$275–325
140-12" vase	$275–350
141-15" vase (I/263)	$850–1000
142-18" floor vase	$1000–1200
201-7" bud vase	$150–175
202-8" vase (I/264)	$175–225
203-6" cornucopia	$125–150
204-8" cornucopia	$150–175
205-6" fan vase	$150–200
206-7" fan vase (I/264)	$175–225
393-7" basket	$175–225
394-8" basket	$225–275
395-10" basket (I/264)	$275–325
470-5" bowl	$150–175
471-6" rose bowl	$175–225
472-5" hanging basket	$275–350
472-6" bowl	$125–150
473-6" bowl	$100–125
474-8" bowl	$150–200
475-10" bowl	$175–225
476-10" bowl	$175–225
477-12" tray	$200–250
478-12" bowl	$225–275
479-14" bowl	$250–300
671-4" jardiniere (I/264)	$125–150
671-6" jardiniere	$150–200
671-8" jardiniere and pedestal	$1200–1400
672-5" flower pot and saucer	$175–225
1162-2" candlestick (pr)	$125–175
1163-4.5" candlestick (pr)	$150–200
1297-8" wall pocket	$275–350
1393-8" window box	$175–225

*Comprehensive shape list (see page 12)

WOODLAND

812-13.5" vase, Rozane Royal shape,
 woodland wafer (I/2) $2000–2500

822-15.75" vase (Rozane Royal shape),
 hollyhocks (I/31/3/4) $2000–2500

892-8.25" vase (Rozane Royal shape),
 pansies (I/262/2) $950–1200

970-10" vase (Rozane Royal shape),
 poppy (I/32/1/4) $950–1200

972-8" vase (Rozane Royal shape),
 flower (I/263/1/1) $750–950

R22-3.5" letter holder (Rozane Royal
 shape), daisies (I/262/1) $650–750

W6-8.25" vase, berries (I/263/1/2) $750–950

W15-10.25" vase, daisies (I/262/3) $950–1200

W961-10.5" vase, iris (I/263/1/3) $950–1200

W974-11.5" vase, daisy (I/32/1/2) $750–950

W976-6.5" vase, flower (I/262/4) $700–800

*WISTERIA

	Blue	Brown
242-4" rose bowl	$400–500	$350–400
243-9" x 5" bowl	$600–700	$500–600
254-4" rose bowl	$500–600	$400–500
351-5" hanging basket	$1500–1800	$1200–1500
628-8" x 24.25" jardiniere and pedestal	$5000–6000	$4000–5000
629-4" vase (I/260)	$400–500	$350–400
630-6" vase	$500–600	$450–500
631-6" vase	$500–600	$450–500
632-5" vase (I/261)	$500–600	$450–500
633-8" vase (I/261)	$800–900	$650–750
634-7" vase	$750–850	$600–700
635-8" vase (I/261)	$700–800	$550–650
636-8" vase (I/261)	$800–900	$650–750
637-6.5" vase	$750–850	$600–700
638-9" vase (I/260)	$850–950	$700–800
639-10" vase	$1200–1400	$1000–1200
640-12" vase (I/261)	$1500–1800	$1400–1600
641-15" vase	$2750–3250	$2200–2600
680-8" vase (I/261/1/1)	$850–1000	$800–900
681-9" vase (Huxford I/97/4/2)	$850–1000	$800–900
682-10" vase (I/261/2/1)	$950–1200	$850–1000
1091-4" candlestick (pr)	$750–850	$650–750
1271-8.5" wall pocket	$1500–1800	$1200–1500

*Comprehensive shape list (see page 12)

*WINDSOR

	Blue	Brown
224-10" bowl (I/260)	$400–500	$350–400
329-4" basket	$600–700	$500–600
330-5" basket	$700–800	$600–700
331-8" basket (I/260)	$800–900	$700–800
545-5" vase (I/260)	$450–550	$375–450
546-6" vase	$500–600	$400–500
547-6" vase (I/260)	$550–650	$450–550
548-7" vase (I/260)	$600–700	$500–600
549-7" vase, fern (I/259 and 260)	$800–900	$700–800
550-7" vase (I/260)	$850–950	$750–850
551-7" vase, fern	$900–1000	$800–900
552-8" vase (I/259)	$800–900	$700–800
553-9" vase	$1000–1200	$900–1000
554-10" vase	$1200–1400	$1000–1200
582-9" vase (Huxford I/91/3/5)	$1000–1200	$900–1000
583-7" x 9.75" vase (Huxford II/119/4/2)	$1200–1400	$1000–1200
1084-4" candlestick (pr)	$600–700	$500–600
6" (?) bowl (Huxford II/119/3/3)	$325–375	$275–325
7" (?) bowl (Huxford II/119/3/1)	$450–500	$375–450
7" bowl (I/259)	$350–450	$275–350
15" vase, fern	$1600–1800	$1400–1600

*Comprehensive shape list (see page 12)

*WINCRAFT

208-8" basket	$175–225
209-12" basket	$225–275
210-12" basket	$275–350
216-8" (or 2TK-8") ewer	$175–200
217-6" ewer	$125–150
218-18" ewer	$375–450
221-8" cornucopia (I/258)	$95–125
222-8" cornucopia (I/258)	$125–150
226-8" bowl	$150–175
227-10" (or 2BL-10")bowl	$175–200
228-12" bowl	$200–225
229-14" bowl	$225–250
230-7" tray	$100–125
231-10" bowl	$200–225
232-12" bowl	$175–200
233-14" bowl	$250–300
240-B cigarette box, covered	$125–150
240-T ashtray	$75–100
241-6" (or 2RB-6") rose bowl	$125–175
242-8" rose bowl (I/259)	$150–200
250-C creamer	$75–85
250-P coffee pot	$225–275
250-S sugar bowl	$75–85
251-3" (or 2CS1) candlestick (pr)	$125–150
252-4" candlestick (I/258) (pr)	$100–125
253 triple candelabra	$150–175
256-5" (or 2PT-5") flower pot	$150–175
257-6" flower pot	$150–175
259-6" bookend (I/258) (pr)	$175–225
261-6" hanging basket	$175–225
263-14" vase	$300–350
266-5" wall pocket, flower pot shape	$200–250
267-5" wall pocket	$275–325
268-12" window box	$150–200
271-C creamer	$65–75
271-P teapot	$200–250
271-S sugar bowl	$65–75
272-6" fan vase (I/36)	$125–150
273-8" (or 2FH-8") fan vase	$125–150
274-7" vase	$125–150
275-12" pillow vase	$225–275
281-6" bud vase	$100–125
282-8" vase	$125–150
283-8" (or 2V2-8") vase (I/36)	$125–150
284-10" (or 2V1-10") vase	$150–200
285-10" (or 2V2-10) vase (I/258)	$150–200
286-12" vase (I/258)	$200–250
287-12" vase	$250–300
288-15" vase (I/258)	$450–550
289-18" floor vase (I/259)	$650–750
290-11" vase, panther (I/28)	$800–900

*Comprehensive shape list (see page 12)

*WHITE ROSE

1 cornucopia	$150–200
1-C creamer (I/257)	$75–95
1-S sugar (I/257)	$75–95
1-T teapot (I/257)	$325–375
7 bookend (I/257) (pr)	$225–275
41 flower frog	$125–150
143-6" cornucopia	$150–175
144-8" cornucopia	$175–200
145-8" double cornucopia	$175–225
146-6" vase	$125–150
147-8" vase	$150–175
148-4.5" gate (I/256)	$125–175
362-8" basket	$175–225
363-10" basket	$225–275
364-12" basket	$275–325
382-9" window box (I/257)	$125–175
387-4" rose bowl (I/257)	$95–125
388-7" rose bowl	$225–275
389-6" bowl	$125–150
390-8" bowl	$150–175
391-10" bowl	$175–200
392-10" bowl	$175–200
393-12" bowl	$200–250
394-14" bowl	$250–300
463-5" hanging basket	$275–350
653-3" jardiniere	$100–125
653-4" jardiniere	$125–150
653-5" jardiniere	$150–175
653-6" jardiniere	$175–225
653-7" jardiniere	$250–300
653-8" jardiniere and pedestal	$1000–1200
653-10" jardiniere and pedestal	$1200–1500
654-5" flower pot and saucer	$175–225
978-4" vase (I/256)	$100–125
979-6" vase	$125–150
980-6" vase	$125–150
981-6" ewer	$150–175
982-7" vase (I/257)	$150–200
983-7" vase (I/257)	$150–200
984-8" pillow vase	$225–275
985-8" vase	$200–250
986-9" vase	$250–300
987-9" fan vase	$250–300
988-10" vase	$275–325
990-10" ewer (I/257)	$275–325
991-12" vase	$350–425
992-15" vase	$500–600
993-15" ewer (I/8)	$500–600
994-18" floor vase	$850–1000
995-7" bud vase (I/256)	$95–125
1141 candlestick (pr)	$125–150
1142-4.5" candlestick (pr)	$150–175
1143 double candelabra	$150–175
1288-6" wall pocket	$300–350
1289-8" wall pocket	$350–400
1324 pitcher	$275–350

*Comprehensive shape list (see page 12)

*WATER LILY

1-8" cookie jar (I/8)	$450–500
10-6" ewer	$150–200
11-10" ewer	$225–275
12 bookend (pr)	$250–325
12-15" ewer	$450–550
48 flower holder	$150–175
71-4" vase (I/255)	$95–125
72-6" vase	$125–150
73-6" vase	$125–150
74-7" vase	$150–175
75-7" vase	$150–175
76-8" vase	$175–225
77-8" vase (I/27 and 256)	$200–250
78-9" vase (I/255)	$225–275
79-9" vase	$225–275
80-10" vase	$225–275
81-12" vase	$275–350
82-14" vase (I/255)	$375–450
83-15" vase	$450–500
84-16" vase (I/255)	$550–650
85-18" floor vase	$850–1000
174-6" vase (I/255)	$150–200
175-8" vase	$175–225
176-6" fan vase	$150–200
177-6" cornucopia	$125–150
178-8" cornucopia	$150–200
380-8" basket	$200–250
381-10" basket (I/255)	$250–300
382-12" basket	$275–350
437-4" rose bowl	$125–150
437-6" rose bowl (I/256)	$150–200
438-8" conch shell	$200–250
439-6" bowl (I/256)	$95–125
440-8" bowl	$150–175
441-10" bowl	$175–200
442-10" bowl	$175–200
443-12" bowl	$200–250
444-14" bowl	$250–300
445-6" conch shell	$150–200
468-5" hanging basket	$250–300
663-3" jardiniere	$100–125
663-4" jardiniere	$125–150
663-5" jardiniere (I/256)	$150–175
663-8" jardiniere and pedestal	$1000–1200
663-10" jardiniere and pedestal	$1200–1500
664-5" flower pot and saucer	$225–275
1154-2" candlestick (pr)	$150–175
1155-4.5" candlestick (pr)	$175–200

*Comprehensive shape list (see page 12)

*VOLPATO

2-5.5" compote	$225–275
3-8" covered vase (I/34)	$300–350
5-10" covered vase	$400–500
12-8" compote (I/254)	$225–275
13-10" compote	$250–300
14-4" compote, shown only in Savona pages	$125–150
97-4" rose bowl	$150–200
98-5" bowl	$100–125
99-5" bowl	$100–125
100-6" bowl	$125–150
101-6" bowl	$125–150
102-6" bowl	$125–150
103-8" bowl	$150–175
104-10" bowl	$175–200
105-14" bowl (I/254)	$225–275
119-6" bowl	$125–150
120-8" bowl	$200–250
188-5" vase	$125–150
189-7" vase (I/254)	$200–250
190-9" vase	$225–275
191-10" vase	$250–300
192-12" vase	$325–400
206-6" vase	$150–175
207-6" vase	$150–175
208-8" vase	$225–275
209-10" vase	$225–275
599-6" flower pot and saucer	$225–275
1039-8" candlestick	$150–175
1040-8" candlestick	$150–175
1041-10" candlestick (I/254) (pr)	$400–500
1042-10" candlestick	$175–200
1043-12" candlestick	$200–250
1046-10" candlestick	$175–200
1047-12" candlestick	$200–250
5-part centerpiece (I/254/1) (set)	$400–500
9" x 2.5" window box (Huxford II/95/4/1)	$150–200

*Comprehensive shape list (see page 12)

*VISTA

120-18" floor vase (I/252/3/3)	$1500–1800
121-15" vase (I/252/3/4)	$1200–1500
122-15" vase (I/252/1/2)	$1200–1500
123-15" vase (Bomm 148/2/3)	$1200–1500
124-18" floor vase (I/251)	$1500–1800
125-12" vase (I/253/1/3)	$950–1200
126-10" vase (I/253/1/2)	$950–1200
127-10" vase (I/252/1/4)	$750–850
129-12" vase (Bomm 147/3/3)	$950–1200
130-10" vase (I/252/3/2)	$600–700
131-15" vase	$1200–1500
132-18" floor vase (I/252/1/3)	$1800–2200
133-12" vase (I/253/2/1)	$950–1200
134-18" floor vase (I/252/3/1)	$1500–1800
249-7" x 4" fern dish (I/253/2/3)	$275–350
256-10" basket	$1000–1200
257-6.5" basket (I/252/2/1)	$600–700
260-8" basket (I/253/2/2)	$750–950
331-6" hanging basket (I/253/3/2)	$450–550
331-7" hanging basket (I/253/3/1)	$600–700
368-10" window box (I/10/2)	$950–1200
589-6" jardiniere (I/253/2/3)	$400–500
589-10" jardiniere (I/20/2/1)	$850–1000
589-10" x 28" jardiniere and pedestal (Huxford II/183/1/3)	$2000–2500
589-12" x 36" jardiniere and pedestal	$3000–3500
757-20" umbrella stand (I/252/1/1)	$1800–2200
1216-9" wall pocket (Bomm 148/1/3)	$1000–1200
6.5" basket (I/253/1/1)	$600–700
8" basket (I/253/1/4)	$750–950
9.5" basket (1/252/2/2)	$750–950
12" basket (Huxford II/93/1/1)	$1200–1500

*Comprehensive shape list (see page 12)

*VINTAGE

NOTE: Add 25–50% for green.

9-3" vase (I/250)	$150–175
48-4.5" gate	$200–250
139-3" bowl (I/250)	$95–125
140-4" bowl	$150–175
141-5" bowl (I/250)	$125–150
142-6" bowl	$150–175
143-3" rose bowl	$175–225
144-6" rose bowl (I/250)	$175–225
273-4" vase	$175–225
274-5" vase	$200–250
275-6" vase	$225–275
276-6" vase	$250–300
277-8" vase	$325–375
278-8" vase	$375–450
279-10" vase	$450–550
280-12" vase	$575–650
372-10" window box (I/251)	$350–400
607-5" jardiniere (I/251)	$200–250
607-6" jardiniere	$250–300
607-7" jardiniere	$325–375
607-8" jardiniere	$375–450
607-9" jardiniere	$450–550
607-10" jardiniere and pedestal	$1200–1500
1241-8" wall pocket	$400–500
6" bowl (Huxford I/75/1/5)	$125–150
8" candlestick (I/251)	$150–200
9" wall pocket (Huxford II/164/4/4)	$400–500

*Comprehensive shape list (see page 12)

*VICTORIAN ART POTTERY

132-4" rose bowl (I/249)	$250–300
133-6" rose bowl	$300–350
256-6" vase	$375–450
257-7" vase (I/250)	$425–475
258-7" vase (I/249)	$450–550
259-7" vase	$450–500
260-8" vase	$500–550
261-8" covered vase (I/250)	$550–650
262-10" vase	$600–700
263-10" vase (I/249)	$700–800
264-9.5" vase (I/249)	$700–800
265-12" vase	$850–1000

*Comprehensive shape list (see page 12)

*VELMOSS

NOTE: Add 25–30% for tan.

115-7" bud vase (I/247)	$175–225
116-8" double bud vase (I/247)	$250–300
117-8" double cornucopia	$225–275
119-10" vase	$375–450
264-5" rose bowl (I/248)	$200–250
265-6" rose bowl	$250–300
266-8" x 5" bowl	$125–175
266-12" x 6" bowl	$175–225
714-6" vase (I/248)	$225–275
715-7" vase (I/247)	$225–275
716-7" vase	$225–275
717-8" vase	$275–325
718-8" vase	$300–350
719-9" vase	$350–400
720-10" vase	$375–450
721-12" vase (I/248)	$500–600
722-14" vase (I/248)	$750–850
1100-4.5" candlestick (pr)	$200–250
1274-8" wall pocket	$1800–2000

*Comprehensive shape list (see page 12)

VASE ASSORTMENT

105-8.5" vase, green (I/247) $250–300
105-8.5" vase, green, hand decorated (I/247) $300–350
106-7.75" vase, green (I/247) $300–350
107-8" vase, tan, hand decorated (I/247) $350–400
109-7.25" ewer, tan (I/246) $250–300

UTILITY WARE *(cont.)*

Tulip 7.5" pitcher, Majolica (Blended Colors) (I/245)	$225–275
Tulip 7.5" pitcher, Majolica (Hand Decorated) (I/245)	$225–275
Tulip 7.5" pitcher, Volpato glaze (I/245)	$225–275
Wild Rose 9.5" tankard, blue Cornelian glaze (I/246)	$200–250
Wild Rose 9.5" tankard, combination of Majolica (Hand Decorated) and blue Cornelian glaze (I/246)	$200–250
Wild Rose 9.5" tankard, gold Cornelian glaze (I/246)	$200–250
Wild Rose 9.5" tankard, Majolica (Hand Decorated) (I/246)	$200–250

Romafin

241.5-3" Astor tea pot, 8 oz., black (I/243)	$95–150
242.5-3.25" Astor tea pot, 16 oz., black (I/243)	$95–150
243.5-3.25" Astor tea pot, 32 oz., black (I/243)	$95–150
244.4-3.5" Astor tea pot, 48 oz., black (I/243)	$95–150

Venitian

3.5" pudding dish, brown (I/246)	$60–75
9" baking dish, brown (I/246)	$25–30
9.75" crock, blue, with bail handle (I/245)	$75–95
11" baking dish, brown (I/246)	$30–40

Creamware (Banded)

1-5" baking dish, narrow gray band (I/243)	$60–75
1-8" baking dish, narrow gray band (I/243)	$75–95
1-10" baking dish, narrow gray band (I/243)	$95–125
13-7" pitcher, wide blue band (I/242)	$125–150

German Cooking Ware

3" cream pitcher (I/243)	$20–25
7" teapot (I/243)	$75–95
8.5" coffee pot (I/243)	$75–95

Glossy Utility Ware

14C creamer (I/244)	$40–50
14S sugar bowl (I/244)	$40–50
14T teapot (I/244)	$125–175
20-10" cookie jar (I/244)	$125–175

Ideal Pitchers

3-5.5" pitcher, 1.75 pt., glossy pink and cream (I/30)	$125–150
5-6.75" pitcher, 5 pt., glossy blue and cream (I/242)	$125–150

Lilies of the Valley

1318-4" pitcher, 0.5 pt. (I/245)	$125–150
1319-5.5" pitcher, 1.5 pt. (I/245)	$150–175
1320-7.25" pitcher, 4 pt. (I/245)	$175–200

Miscellaneous

Holland 4" mug, boy with sailboat, Majolica (Hand Decorated) (I/244)	$75–95
Holland 4" mug, standing girl, Majolica (Blended Colors) (I/244)	$75–95
Holland 4.25" mug, standing boy, Majolica (Hand Decorated) (I/244)	$75–95
Holland 5" mug, running boy, Majolica (Hand Decorated) (I/244)	$75–95
Holland 6" pitcher, Majolica (Hand Decorated) (I/244)	$125–150
Landscape 7.5" pitcher, Majolica (Blended Colors) (I/30)	$150–200
Landscape 7.5" pitcher, Majolica (Hand Decorated) (I/30)	$175–225
Teddy Bear 7.5" pitcher, Majolica (Hand Decorated) (I/245)	$2000–2500

*TUSCANY

NOTE: Add 20–25% for green.

[15]-2.5" flower block (I/239)	$30–40
[15]-3.5" flower block (I/239)	$35–45
66-5" flower holder (I/239)	$125–150
67-4" vase	$100–125
68-4" vase	$125–150
69-5" flower holder	$125–150
70-5" pillow vase (I/239)	$150–200
71-6" vase	$150–200
80-8" fan vase (Huxford I/79/4/1)	$225–275
171-6" bowl	$125–150
172-9" bowl (I/239)	$150–200
173-10" bowl	$175–225
174-12" bowl	$200–250
341-5" vase (I/239)	$175–225
342-6" vase (I/238)	$175–225
343-7" vase	$200–250
344-8" vase (I/238)	$250–300
345-8" vase	$250–300
346-9" vase (I/239)	$325–375
347-10" vase	$400–500
348-10" vase	$475–550
349-12" vase (I/239)	$600–700
615-5" flower pot and saucer	$225–275
615-6" flower pot and saucer	$250–300
1066-3.5" candlestick (pr)	$125–175
1067-4" candlestick (pr)	$150–200
1254-7" wall pocket	$350–400
1255-8" wall pocket	$375–425

*Comprehensive shape list (see page 12)

TRIAL GLAZES

NOTE: Roseville trial glaze pieces typically have alpha-numeric notations in pencil or crayon. Some experimental Roseville pieces also have such notations. In the George Krause Family collection are trial glaze samples without any glaze notation.

Caution: The hand-written numbers on Roseville lamps seem to refer to shape numbers, **not** to glazing or firing instructions. Roseville lamps often use interesting glazes and are best viewed separately from trial glazes, as a category all their own

Corinthian 217-8" vase, rust and brown
 (I/27/1/4) $500–600
Dogwood (Smooth) 135-8" vase, dark
 and light brown (I/27/2/4) $400–500
Mock Orange 982-8" vase, glossy mustard
 yellow and green, no longer thought to
 be a Trial Glaze, but a standard 1954–1955
 glaze, used only on items that were
 glaze-fired by the New England Ceramics
 Company (Torrington, CT) (I/27/3/4) $400–500
Primrose 767-8" vase, glossy blue (I/27/1/1) $300–350
Silhouette 785-9" vase, peach and green,
 slightly different coloring on obverse
 (I/27/3/2) $375–450
Water Lily 77-8" vase, pink and brown (I/27/2/1) $450–550

*TOURMALINE

17-4.5" x 3" flower frog, a Carnelian shape	$65–75
105-8" vase, shown only in Ivory pages	$175–225
106-7" cornucopia, shown only in Ivory pages (I/238)	$125–175
152-6" bowl, a Carnelian shape	$100–125
238-5" rose bowl, also an Ivory shape	$150–200
241-12" bowl	$200–250
611-6" vase	$150–200
612-7" vase	$175–225
613-8" vase	$200–250
614-8" vase	$250–300
615-9" vase	$225–275
616-10" vase	$275–350
679-6" vase (I/237)	$125–150
1089-4.5" candlestick (pr)	$125–175
A65-6" pillow vase, a Carnelian shape (I/237)	$150–200
A152-7" bowl, a Carnelian shape	$150–200
A200-4" bowl, an Imperial (Glazes) shape (I/237)	$150–175
A308-7" vase, a Carnelian shape (I/237)	$125–150
A332-8" vase, a Carnelian shape	$200–250
A425-8" vase, derived from Futura shape	$225–275
A429-9" vase, derived from Futura shape	$250–300
A435-10" vase, a Futura shape (I/33/3/1)	$350–400
A444-12" vase, a Carnelian shape (I/237)	$350–400
A517-6" vase, an Earlam shape (I/34/1/3 and 4)	$125–150

*Comprehensive shape list (see page 12)

*TOPEO

245-6" rose bowl (I/236)	$300–400
246 bowl, 3" t. (I/236)	$200–250
249-12" bowl (shown only in Ivory pages)	$350–450
656-6" vase	$275–325
657-6.75" vase	$300–350
658-7.25" vase	$325–375
659-8" vase (I/236)	$400–500
660-8.25" vase (I/236)	$375–450
661-9.25" vase	$450–550
662-9" vase	$450–550
663-10" vase	$500–600
664-12.25" vase (I/236)	$650–750
665-14.25" vase	$850–1000
666-15" vase	$1500–1800
1093-4" candlestick (I/236) (pr)	$250–300
1095-5" double candelabra, shown only in Ivory pages (pr)	$550–650
6" bowl (Huxford I/101/1/2)	$175–225
9" bowl (I/236/2/2)	$275–350

*Comprehensive shape list (see page 12)

*THORN APPLE

3-5.5" bookend (pr)	$275–350
29 flower frog	$125–175
30 flower frog	$150–200
127-6" cornucopia	$100–125
262-5" fern dish	$125–150
304-4" rose bowl	$150–200
305-6" rose bowl	$200–250
306-5" bowl (I/234)	$125–150
307-6" bowl	$125–150
308-7" bowl	$150–175
309-8" bowl	$175–225
310-10" bowl	$225–275
311-12" bowl	$250–300
312 centerpiece	$275–325
313 centerpiece	$300–400
342-10" basket (I/235)	$275–350
343-12" basket	$350–400
355-5" hanging basket	$350–400
356-4" hanging flower pot, wall pocket shape	$700–800
382-14" window box	$275–325
638-4" jardiniere	$100–125
638-5" jardiniere	$125–150
638-6" jardiniere	$150–200
638-7" jardiniere	$250–300
638-8" jardiniere and pedestal	$1000–1200
638-9" jardiniere	$450–550
638-10" jardiniere and pedestal	$1200–1500
638-12" jardiniere and pedestal	$1800–2200
639-5" flower pot and saucer	$400–500
774-12" x 8" floor vase	$600–700
775-14" x 10" sand jar	$850–1000
808-4" vase	$175–225
809-5" vase	$200–250
810-6" vase (I/235)	$175–225
811-6" vase	$200–250
812-6" pillow vase (I/234)	$175–225
813-7" bud vase (I/235)	$175–225
814-7" vase	$200–250
815-7" vase	$225–275
816-8" vase (I/235)	$250–300
817-8" vase	$225–275
818-8" vase	$250–300
819-9" vase	$275–325
820-9" vase	$250–300
821-10" vase	$275–325
822-10" vase	$300–400
823-12" vase (I/234)	$500–600
824-15" vase (I/235)	$950–1200
825-15" ewer (I/235)	$850–1000
835-5" vase	$225–275
1117 candlestick (pr)	$175–225
1118-4.5" candlestick (pr)	$225–275
1119-5" double candelabra	$200–250
1120-5.5" triple candelabra	$225–275
1280-8" wall pocket	$500–600

*Comprehensive shape list (see page 12)

36 flower frog (I/234)	$95–125
342-4" rose bowl	$150–175
343-6" rose bowl	$200–250
344-8" bowl	$200–250
345-12" bowl	$250–300
349-10" basket	$275–325
644-4" jardiniere (I/234)	$125–150
881-6" vase (I/233)	$150–175
882-6" vase (I/233)	$150–175
883-7" vase (I/233)	$175–225
884-8" vase (I/36 and 234)	$225–275
885-8" pillow vase	$200–250
886-9" fan vase (I/233)	$250–300
887-10" vase	$275–350
888-12" vase	$400–500
889-15" vase (I/234)	$700–800
890-18" ewer	$750–850
1131 candlestick (pr)	$150–175

*Comprehensive shape list (see page 12)

*SYLVAN

15-3.5" flower block, same as Mostique (I/232)	$30–35
225-4" fern dish	$125–175
225-5" fern dish	$150–200
225-6" fern dish (I/233)	$175–225
325-4" hanging basket	$200–250
325-5" hanging basket	$250–300
325-6" hanging basket	$275–325
325-7" hanging basket	$350–400
325-8" hanging basket	$400–500
325-10" hanging basket	$450–550
362-11.5" x 6.5" window box	$250–300
362-14" x 8" window box	$350–425
362-16.5" x 8.5" window box	$450–550
568-9" jardiniere (Huxford II/47/1/3)	$600–700
568-10" jardiniere (I/233)	$700–800
568-12" x 33" jardiniere and pedestal	$1500–1800
750-21" umbrella stand (I/232)	$1200–1500
S33-7" x 6" flower pot, square	$250–300
S34-5.75" x 5" flower pot, square	$200–250
S35-4.5" x 4" flower pot, square	$125–175
S36-5.5" x 2.25" fern dish, triangular	$175–225
S37-4.5" x 1.75" fern dish, square	$150–200
S38-8" x 2.75" x 2.5" window box	$250–300
S39-7" x 5.5" x 2.5" planter, pillow vase shape	$200–250
S40-6" x 3" x 1.75" oblong bowl	$175–225
S41-7.5" x 3.25" x 2.25" oblong bowl	$250–300
S42-12" x 6.5" x 3" oblong bowl (I/232)	$350–450
9.5" vase, no shape number in factory stock pages (I/232)	$650–750

*Comprehensive shape list (see page 12)

*SUNFLOWER

208-5" rose bowl	$700–800
213-4" rose bowl (Huxford II/109/1/1)	$600–700
346-5" hanging basket (I/231/1)	$1200–1500
346-6" hanging basket	$1500–1800
485-6" vase (I/231)	$650–750
486-5" vase (I/231)	$750–850
487-7" vase (I/231)	$750–850
488-6" vase (I/231)	$950–1200
489-7" vase	$1200–1400
490-8" vase (I/231)	$1200–1400
491-8" vase	$1200–1400
492-10" vase	$1400–1600
493-9" vase	$1200–1400
494-10" vase (I/231)	$1400–1600
512-5" vase (I/231/3/3)	$550–650
513-5" vase (Huxford II/109/1/2)	$600–700
514-6" vase (Huxford II/109/3/3)	$700–800
566-4" vase	$500–600
619-6" jardiniere (Huxford II/109/4/3)	$850–1000
619-9" jardiniere (Huxford I/85/4/2)	$2000–2500
619-10" jardiniere and pedestal	$5000–6000
619-12" jardiniere	$3500–4000
770-20" umbrella stand	$5000–6000
1079-4" candlestick (Huxford II/109/2/1)	$600–700
1265-7" wall pocket	$1500–2000
12.5" x 3" bowl (Huxford II/109/2/2)	$1000–1200
11" bowl (I/231/2/2)	$950–1200

*Comprehensive shape list (see page 12)

*SOLID COLORS

22 ashtray	$50–60
236-3" vase (I/230)	$50–60
236-4" vase	$60–75
364-5" hanging basket	$125–175
548-4" flower pot, a Matt Green shape (I/230)	$50–60
549-4" flower pot, a Matt Green shape	$50–60
550-4" jardiniere (I/230)	$60–75
607-4" vase (I/230)	$60–75
608-6" vase (I/230)	$75–95
609-6" vase	$100–125
624-4" flower pot	$60–75
625-5" jardiniere (I/230)	$60–75

*Comprehensive shape list (see page 12)

*SNOWBERRY

1AT ashtray	$100–125
1BE bookend (pr)	$250–300
1BK-7" basket (I/229)	$175–225
1BK-8" basket	$200–250
1BK-10" basket (I/229)	$250–300
1BK-12" basket	$300–400
1BL-8" bowl	$125–175
1BL-14" bowl	$225–275
1BL1-6" bowl	$125–150
1BL1-10" bowl	$125–175
1BL1-12" bowl	$175–225
1BL2-6" bowl	$100–125
1BL2-10" bowl	$150–175
1BL2-12" bowl	$150–200
1BV-7" bud vase	$125–150
1C creamer	$75–85
1CC-6" cornucopia	$125–150
1CC-8" cornucopia	$150–175
1CS1-2" candlestick (I/229) (pr)	$100–125
1CS2-4.5" candlestick	$125–175
1FB-10" fruit bowl	$175–225
1FH-6" flower holder	$125–175
1FH-7" flower holder (I/229)	$150–200
1HB-5" hanging basket	$225–275
1J-4" jardiniere (I/229)	$125–150
1J-6" jardiniere	$150–200
1J-8" jardiniere and 1P-8" pedestal	$1000–1200
1PS-5" flower pot and saucer	$175–225
1RB-5" rose bowl	$125–150
1RB-6" rose bowl	$150–175
1S sugar bowl	$75–85
1TK-6" ewer (I/229)	$125–175
1TK-10" ewer	$250–300
1TK-15" ewer	$550–650
1TP teapot	$350–400
1UR-8" urn	$175–225
1V-6" vase	$100–125
1V-15" vase (I/228)	$600–700
IV-18" floor vase	$850–1000
1V1-8" vase	$175–200
1V1-7" vase	$125–150
1V1-8" vase (I/229)	$150–200
1V1-9" vase	$200–250
1V1-10" vase	$250–300
1V1-12" vase	$350–450
1V2-7" vase	$125–150
1V2-8" vase	$175–200
1V2-9" vase	$200–250
1V2-10" vase (I/229)	$250–300
1V2-12" vase	$350–450
1WP-8" wall pocket	$275–325
1WX-8" x 2.5" window box (I/229)	$150–200

*Comprehensive shape list (see page 12)

*SILHOUETTE

708-6" basket (I/227)	$150–200
709-8" basket (I/227)	$225–275
710-10" basket	$275–350
716-6" ewer	$125–175
717-10" ewer (I/228)	$175–225
721-8" cornucopia	$125–175
722-8" cornucopia (I/227)	$125–175
726-6" bowl	$100–150
727-8" bowl	$125–175
728-10" bowl	$125–175
729-12" bowl (I/228)	$150–200
730-10" window box	$125–175
731-14" window box	$175–225
740-4" cigarette box (covered)	$125–175
741-4" rose bowl	$100–150
742-6" rose bowl, nude (I/227)	$500–600
751-3" candlestick (pr)	$125–175
756-5" planter	$100–150
757-9" double planter	$125–175
761-4" hanging basket	$175–225
763-8" vase, nude	$750–850
766-8" wall pocket (I/228)	$275–350
768-8" window box	$150–200
769-9" window box	$175–225
779-5" vase	$125–150
780-6" vase	$150–175
781-6" vase	$125–150
782-7" vase	$150–175
783-7" fan vase, nude (I/227)	$650–750
784-8" vase	$150–200
785-9" vase (I/227)	$175–225
786-9" vase	$225–275
787-10" vase, nude (I/227)	$850–1000
788-12" vase	$300–350
789-14" vase	$400–450
799 ashtray (I/228)	$85–100

*Comprehensive shape list (see page 12)

13-4" covered bowl (I/226)	$275–325
14-4" compote	$175–225
15-2.5" flower block	$65–75
15-3.5" flower block	$75–85
102-6" bowl	$125–175
119-6" bowl	$150–200
183-10" bowl	$200–250
184-12" bowl	$225–275
185-6" bowl (I/226)	$175–225
186-8" bowl	$175–225
207-6" vase	$200–225
209-10" vase (I/226)	$275–325
222-12" vase (I/226)	$375–425
371-6" vase	$225–250
372-6" vase (I/226)	$200–250
373-8" vase	$250–300
374-8" vase (I/226)	$250–300
375-10" vase	$325–375
376-10" vase	$325–375
377-11" vase (I/226)	$325–375
378-8" vase (I/226)	$400–500
379-12" vase (I/226)	$400–500
1070-3.5" candlestick (pr)	$175–225
1071-4" candlestick (pr)	$200–250
1260-8" wall pocket	$375–450

*Comprehensive shape list (see page 12)

*RUSSCO

Note: Add 20–25% for strongly crystalline green examples.

15-2.5" flower block	$75–85
15-3.5" flower block	$85–100
107-8" double bud vase (I/224)	$150–200
108-7" vase (I/225)	$225–275
109-8" vase (I/225)	$225–275
110-7" cornucopia	$175–225
111-8" x 12" triple cornucopia	$275–350
259-6" rose bowl (I/225)	$175–225
260-6" bowl	$125–175
260-8" bowl	$150–200
260-12" bowl	$175–225
337-10" basket (I/224)	$250–300
694-7" vase (I/225)	$175–225
695-8" vase (I/224)	$200–250
696-8" vase (I/225)	$200–250
697-8" vase	$225–275
698-9" vase	$250–300
699-9" vase (I/225)	$275–325
700-10" vase	$275–325
701-10" vase	$300–350
702-12" vase (I/224)	$500–600
703-15" vase	$850–1000
1098-4.5" candlestick (pr)	$200–250
1101-4.5" candlestick (pr)	$175–225

*Comprehensive shape list (see page 12)

R19-5.25" vase, roses, artist signature W
Myers (I/34/3/1) $300–350

7.25" pitcher (L), nasturtiums, ornate
sprigged-on decoration on spout, rim
and upper portion of handle, artist
initials M.E. (I/31) $2500–3000

9.75" pitcher (L), Utility Ware (Ideal Pitchers)
shape, grapes, ornate sprigged-on
decoration on spout and upper portion
of handle, artist initials HL [Harry
Larzelere] (I/223/1/2) $2000–2500

ROZANE ROYAL

Rozane Royal (Light) examples are noted with an (L).

416-28" jardiniere and pedestal (married), jardiniere with nasturtiums, pedestal with wild roses, artist signed "Myers" (I/220) $950–1200

424-12" x 32" jardiniere and pedestal, chrysanthemums, artist initials WH [William Hall] (I/219) $2200–2500

457-5" jardiniere (L), geranium (I/222) $225–275

809-5.25" bud vase, daisies, bright yellow background (I/222) $200–250

815-20" vase, yellow roses, attributed to Walter Myers (I/31) $1500–1800

815-20" vase (L), white and pale yellow roses, artist signature W [Walter] Myers (I/31) $3000–3500

817-4" bud vase, berries, artist initials A.G. (I/222) $175–225

822-15.75" vase, lilies of the valley, artist signature W Myers (I/31) $1500–1800

829-9" ewer, undecorated (I/222) $275–350

838-7.75" bud vase, undecorated (I/222) $175–225

843-7" vase, pansies, artist signature G [Gussie] Berwick (I/222) $300–400

848-6.75" vase, poppies, artist signed W MYS [Walter Myers] (I/222) $225–275

856-4.5" stein, undecorated (I/222) $125–175

858-15" ewer, leaves and berries, artist initials J.I. [Josephine Imlay] (I/30) $950–1200

862-4.5" bud vase, undecorated (I/222) $125–175

864-8.5" pitcher, corn, artist initials L.M. [Lillie Mitchell] (I/213) $950–1200

882-9" pillow vase, spaniel with pheasant, artist signed "M [Mae] Timberlake" (I/221) $1800–2200

891-14" vase, portrait of John Greenleaf Whittier, artist signature [Anthony] "Dunlavy" (I/222) $3500–4000

892-8.25" vase (L), narcissus (I/222) $275–325

908-5.5" vase, daffodil, illegible artist signature (I/222) $175–225

925A-3.5" bud vase, pansies, restored chip on spout (I/17) $40–50

927-2.5" vase, matches (I/222) $125–150

931-14.75" vase, copy of *Mona Lisa,* artist initials AD [Anthony Dunlavy] (I/222) $3500–4000

931-14.75" lamp, portrait of American Indian chief, artist signature [Anthony] "Dunlavy" (I/222) $4000–4500

968-10.75" vase, wild roses, artist signature "Myers" (I/218) $400–500

983-8" bud vase (L), rosebuds, artist signature W Myers (I/223) $500–600

991-3.25" letter holder (L), playing cards (I/223) $750–950

*ROZANE PATTERN

1 fish ornament (I/217)	$150–175
1-6" vase (I/217)	$95–125
2 cornucopia (I/216)	$125–150
2 flame ornament (I/217)	$150–175
2-6" vase (I/216)	$95–125
3-8" vase (I/217)	$150–175
4-8" vase	$150–175
5-8" vase (I/217)	$150–175
6-9" vase (I/216)	$175–200
7-9" vase (I/216)	$175–200
8-10" vase (I/216)	$200–225
9-10" vase (I/217)	$200–225
10-12" vase (I/217)	$200–250
11-15" vase	$400–500
44 flower frog (I/217)	$125–150
395-9" bowl	$125–150
396-10" bowl (I/217)	$125–150
397-14" bowl	$150–200
398-4" rose bowl (I/217)	$125–150
398-6" rose bowl (I/216)	$150–200
398-8" rose bowl	$200–250
407-6" bowl	$100–125
408-8" bowl	$100–125
409-12" bowl	$150–175
410 conch shell (I/216)	$125–175
1144-3" candlestick (I/217) (pr)	$125–150

*Comprehensive shape list (see page 12)

*ROZANE LINE

1-11" compote ("champagne bucket")	$200–250
1-4" fern dish (Huxford II/81/3/3)	$100–125
1-5" fern dish (Huxford II/81/3/1)	$125–150
1-6" fern dish	$125–150
2-8" compote (I/215)	$125–150
102-8" vase (Huxford II/81/4/2)	$150–200
102-10" vase (Huxford II/81/4/3)	$200–250
102-12" vase	$225–275
244-6" fern dish, scroll handles (I/215/1/1)	$125–150
250-6.25" footed fern dish	$150–200
251-5.5" basket	$175–225
252-8" basket (I/215)	$225–275
330-6" hanging basket	$250–300
367-10" window box	$200–250
588-5" jardiniere	$150–200
588-6" jardiniere (I/214)	$175–225
588-8" jardiniere	$200–250
588-10" jardiniere and pedestal	$850–1000
588-12" x 34.5" jardiniere and pedestal	$1000–1200
756-19" x 9" umbrella stand	$650–750
1016-6" candlestick (I/214)	$75–95
1215-10" wall pocket, measures 7.75" long	$275–350
R108-5.25" vase	$100–125
R109-6" vase (Huxford II/81/1/3)	$100–125
R110-6" vase (I/215)	$125–150
6" basket (Huxford I/67/1/1)	$150–200
8.5" basket (I/215/2/3)	$200–250
11" basket (Huxford I/67/2/2)	$275–350
3" t. bowl (Huxford II/81/1/1)	$75–85
3.5" t. bowl (Huxford II/81/2/3)	$85–100
8" compote (Huxford II/81/1/2)	$175–225
5" cuspidor (Huxford I/67/1/3)	$175–225
6.5" pitcher (I/215/2/1)	$175–225
6.5" vase, loop handles (I/214/2/1)	$150–200
7" vase (Huxford I/67/2/4)	$125–150
8" vase (I/215/3/1)	$150–200
8" vase (Huxford II/81/4/5)	$175–225
10" vase (Huxford II/81/4/4)	$200–250
10" vase, trophy shape (I/215/2/2)	$175–225

*Comprehensive shape list (see page 12)

ROYAL CAPRI

NOTE: In a vintage Royal Capri brochure (by P. & E. Decorators, Roseville, Ohio) the letters "GR" precede each shape number; however, no examples are known to be marked with the letters "GR." (For details, see *Introducing Roseville Pottery*.)

508-7" basket (I/213)	$325–375
526-7" bowl (I/214)	$200–250
554-6" planter (I/213)	$150–200
555-7" planter (I/213)	$200–250
556-6" cornucopia (I/213)	$200–250
578-7" bud vase (I/214)	$200–250
598-9" ashtray (I/213)	$175–225
851-6" vase, glaze trial (I/213)	$275–350
924-4.5" vase, glaze trial (I/214)	$275–350
4" ashtray, round, attributed to Roseville (I/213)	$95–125